ART
&MONEY

FICTION

The Prevalence of Witches
The Stumbling Stone
The Backward Bride
The Duke of Gallodoro
The Ramayana
The Abode of Love
The Fig Tree
SheLa
A Conspiracy of Women
Fonthill

NON-FICTION

Dead Man in the Silver Market
Rome for Ourselves
Speaking the Language Like a Native
India (*with Roloff Beny*)
The Space Within the Heart (*autobiography*)
Upon This Rock
Cities in the Sand
The Mystics (*with Graham Hall*)
London
Venice
Four Days of Naples

Aubrey Menen

ART & MONEY

An Irreverent History

McGRAW-HILL BOOK COMPANY

NEW YORK ST. LOUIS SAN FRANCISCO
TORONTO MEXICO DÜSSELDORF

1 2 3 4 5 6 7 8 9 8 7 6 5 4 3 2 1 0

LIBRARY OF CONGRESS CATALOGING IN PUBLICATION DATA

Menen, Aubrey.
 Art & money.
 1. Art patronage. 2. Art—Marketing. I. Title.
N5205.M46 338.4'7'7 79-18359
ISBN 0-07-041483-1

Book design by Earl Tidwell.

To Graham Hall

Contents

ART & MONEY

An Introduction by Courtesy of Pablo Picasso

The story goes that a young American admirer of Picasso managed to gain entrance to the august presence. Picasso, as usual, was affable to the young, once they could get by the guards around his villa.

Overwhelmed by this kindness, the young man blurted out: "What is it like to be Picasso?"

Picasso asked him to give him a one-dollar bill. The young man did so. Picasso pinned it to a canvas on his easel, took up a brush, and in a minute or two had redesigned the note with his characteristic bold touches. He then signed it. Giving it back to the admirer, he said: "Now your one dollar is worth five hundred dollars. That is what it is like to be Picasso."

I am sure that a large number of lovers of art will hope that the story is not true. They would hope that Picasso was above mere pelf. They would hope that all genuine artists are above the base consideration of money. In fact, they believe that—in a sordidly commercial world—that is what art is all about. Is it? Should an artist think about money, and, if he does, will it affect his art? Among the artists we shall be considering are Phidias, Michelangelo, Raphael, Titian, Rubens, and Monet: all resounding names that I shall call in evidence.

To return to Pablo Picasso. The Victoria and Albert Museum in London has a vast library of books on the fine arts. In its catalogue I have found an explosive little pamphlet by Picasso himself. There are many books about him, but they all skirt around this statement.

It is called "Art Is Business." Apparently Picasso had been pestered by some person, like the young American, asking a question.

"Someone has asked me," Picasso writes, "why hard-headed businessmen pay tens of thousands of pounds for modern art. I tell you one reason: because they are hard-headed."

He goes on to strike out a phrase that should please all idealists. "Art," he says, "is the currency of the infinite"; beautiful words, you will agree, which could well be written upon the walls of art schools.

He then immediately knocks the stuffing out of it.

"I know, because I am very rich, and so I should be."

He explains what he means by *infinite*. Art, as a currency, can never devalue. Suppose, he goes on, all the paintings in the Louvre were destroyed. Never mind. "There would still be Picasso." He could paint masterpieces all over again.

He comes down to cases. "The other day a man paid over £100,000 ($200,000) in a Paris auction for a Gauguin. You think that is too much? That man has other Gauguins in his collection—because he paid over £100,000 for a new one, all his other Gauguins are worth more. The man he beat in the bidding called him on the telephone to thank him. The other man had five Gauguins, and thanks to that record price, he had become richer in five minutes than most people become in five years.

"Paul Gauguin himself would have understood, for he was a stockbroker on the Paris exchange before he became a painter."

He concludes his argument "Those who say 'Why do hard-headed people buy art?' should ask themselves, 'Why do I ask this question? Is it because I am soft-headed?' "

I am sure the unhappy questioner was sorry he ever spoke. Picasso was clearly not an easy man to argue with. But with Picasso safely in the Elysian Fields (talking, no doubt, to Phidias about money), we might object that Picasso lived in a time of turmoil; during his lifetime, money progressively lost its value and something had to

be found to take its place. Possibly, then, art is business only for our own sad times. Was there not a Golden Age when art was practiced, if not for art's sake (since that is a phrase which smacks of preciosity), then for considerations other than money?

Chapter 1

In the
Beginning

There was a Golden Age, but in a very practical sense of the word *Golden*.

In 1922, Howard Carter discovered the virtually untouched tomb of the boy king Tutankhamen. Literally millions of art lovers have seen a selection of the treasures found there, in an exhibition that has toured the world. It consisted of easily movable pieces.

But in the museum at Cairo there are three huge boxes with which the sarcophagus was covered. Each is as big as a small room. Each fits neatly upon the next, and all are covered with gold leaf on which texts are inscribed. They gleam today much as they did when the

tomb was lit by the torches of the funeral party or those of Carter and his band of diggers.

All save one corner of the innermost box. There is a patch about a foot square that does not gleam at all, because the man in charge of the project stole a little of the gold. He mixed some more with copper to conceal his theft. It probably looked all right during the weeks the shrine was still open for inspection. Then the boxes were put into darkness, which the falsifier no doubt hoped would be permanent. The object of the gold and the shrines was, according to the priests, to show the gods what a rich young man Tutankhamen had been and thus to win him in the next world the respect he had enjoyed in this.

Perhaps the man who stole the gold was a skeptic about religious matters. Skepticism was much in the air; the boy whose tomb he was decorating was the son-in-law of Akhnaton, a pharaoh who had tried to abolish the old religion and had failed to substitute one of his own. Or maybe for him it was just a case that art is business, and he had debts to pay and children to feed.

In either case, he was in good company—that of his fellow artists at court. In 1976, the curator of the Cairo museum, going over the jewelry to be shown in the exhibition, took a closer look at a necklace that has been admired as an astonishing work of art by experts ever since it was discovered. He found that the jewels were false, and so was the lapis lazuli. Both were glass.

Now, whoever did that has set a problem which has echoed down the corridors of time—and, mixed with that echo, I like to think I can hear his laughter.

He was so good an artist that, his fake being brought to light in dramatic circumstances and examined by the most knowledgeable judges, it deceived them. Does that make him less of an artist, or more? Should he have been honest, or should he have realized that he was so talented he did not have to be?

But the ancient Egyptians are alien to us. We are astonished by their art, yet we do not love it. Clearly they were capable of frauds for the sake of money, but then they were capable of anything, from the monstrous pyramids to mummifying cats. Our Western artistic culture begins much later, with the Greeks. However much the Greeks borrowed (or learned) from the Egyptians, they transformed it magically. Without them we would have no art at all, or a strangely different one. Let us now turn our inquiry to one of the greatest of their sculptors, Phidias.

His name is immortal, but his works were not. Nothing has come down to us that we can confidently say is from his hand. A statue of Apollo has been fished up from the Tiber so beautiful that some scholars have ascribed it to him. On the other hand, he may have put chisel to stone only rarely. What we do know, on literary evidence, is that he worked in a most exotic (and expensive) medium known as chryselephantine.

This was a combination of ivory and gold, used in great quantities. A wooden frame was first constructed, onto which were fastened sheets of gold and ivory molded to produce the figure of a god or goddess. Two of his productions are well documented. The first is a seated figure of Zeus, of colossal proportions. The

nearest example, in size and posture, that we have today is the statue of Abraham Lincoln in the shrine dedicated to him in Washington. Given the vast difference in the cost of the material used, the figure of Lincoln gives much the same impression as might have been given by the Zeus seen, let us say, in the gloom. It at least provides us an idea of the scale on which Phidias worked.

The second of his known productions is the statue of Athena that stood inside the Parthenon at Athens. He finished the Athena Parthenos in 438 B.C., in the prime of his life. The Athenians admired the statue beyond measure—and rewarded him with exile from which he never returned.

To understand his fate, we must know the background. Greece was not only the familiar peninsula of our maps, with its fingers reaching into the Mediterranean. It was also Ionia, a string of Greek coastal cities in Asia Minor, and it is thought by many that much of the inspiration of Greek art came from there. However that may be, the Ionian Greeks had the misfortune of being conquered by the Persians, the king of that country having imperial ambitions. The Ionians rose in rebellion (499–494 B.C.) but were put down. The Athenians had sent them aid, for which act they became the Persians' enduring enemies. The great names of history tell the rest of the story. Darius invaded European Greece but was defeated at Marathon. Xerxes repeated the attempt but, delayed at Thermopylae by a heroic band of Spartans, lost irretrievably at Salamis to the Athenian fleet. The Ionian cities were freed and formed a league

with their deliverers, the Athenians. This was known as the Confederacy of Delos.

The Persians had been defeated principally at sea. The aim of the Confederacy was to maintain a fleet, under the command of Athens, that would be a permanent bulwark against further invasions. To maintain this, ships and sailors being much more expensive than the unpaid heroes of Thermopylae, a contribution was levied on the members of the Confederacy. The money, in the form of gold, was kept at Athens.

The custom among the Greeks was to use their principal temple as their city treasury. If we can imagine a narrow room behind the statue of Abraham Lincoln, we have a fair picture of the "bank" of the Athenians in normal times.

But the times were not normal. The victory over Xerxes had gone to the Athenians' heads. Even that of the wisest among them, Pericles, was a little turned. The character of Pericles has been much discussed, both by scholars who have believed in speeches that he may or may not have actually delivered (and they are very noble speeches) and by others who have judged him by his acts. These others are of the opinion that he, too, had imperial designs, and aimed to turn his partners in the Confederacy into cities subordinate to the triumphant Athens.

Whatever his ultimate aims, Pericles stole, quite blatantly, the Confederacy's bankroll. He, with the consent of the majority of the free citizens of Athens, decided to build the biggest and most beautiful temple

in all Greece, dedicated, in place of an older and more modest one, to the patron goddess of the city, Athena. This was, and is, the Parthenon.

The Parthenon, ever since it was built, has been considered one of the finest artistic productions of the human race. But it could not have been built if the Athenians had not embezzled the money entrusted to them. Embezzlement has always been considered a most disgraceful act, particularly by people with money. Should the Athenians have been honest (in which case, no Parthenon)? Should they have rebuilt the Parthenon exclusively out of their own pockets (in which case no pinnacle of the art of architecture)? Or should we say that great art is superior to straight dealing in money matters (in which case we would not mind if Gauguin had stolen our money when he was a stockbroker in order to go to the Pacific). The argument is most interesting. I would like to know what Socrates would have made of it, but he does not deal with it and I am not tempted to fill the gap.

Nor were the Athenians. Not only did they embezzle the money, they put the loot on display. Instead of keeping their treasure behind the statue, they put it on the statue itself, in the form of gold plates. The plates were detachable and, because they represented the resources of the city, were punctiliously weighed from time to time.

It was during one of these exercises in practical accountancy that it was found that the amount of gold Phidias had been given did not correspond to the amount he had used. It was assumed that he had stolen

the difference. Six years after the completion of the statue, he was put on trial. It might be thought by a moralist that this was a case of thieves being set to catch a thief, and even the Athenians seem to have considered the charge not quite heavy enough, so they added blasphemy to it. Phidias was accused of putting his own portrait and that of Pericles on the shield that the statue carried. This tipped the balance, and Phidias, acknowledged to be the greatest sculptor in Athens, was banished from the city. It would seem that this disgrace did not dim his genius, for he is recorded as having worked busily and successfully elsewhere.

It is quite possible that Phidias was not guilty of theft: maybe, as a friend of Pericles, he was too involved in Athenian politics, and the enemies of Pericles struck at him before they overthrew his protector. What is interesting is that Phidias, although a consummate artist, was not surrounded with any public mystique. He was regarded as a citizen, like anybody else. Skilled as he was with the chisel, he accepted the essentially businesslike post of Works Superintendent of the Parthenon.

It is instructive to study what the superintendent's job was. The Parthenon today inspires us with deeply aesthetic emotions: we admire its harmony, its purity of line, and particularly its classic restraint. But we see it after the centuries have washed it as clean as a seashore pebble. The superintendent's job was to make something that would knock the visitor's eye out. It is only today, in our own time, that we can catch a glimpse of what he actually did.

In 1976 the British Museum opened a very small

gallery, still largely ignored by the public, that displays lumps taken from the Parthenon, some by Lord Elgin (of the famous marbles) and some by others. There is one piece, about two feet long and eighteen inches high, taken from a frieze. On it, still to be dimly discerned, are the colors with which it was originally painted. Beneath it is a stucco reproduction, the same size, with the colors restored to their pristine state. They are as garish as the paintings on an old-fashioned merry-go-round. Not even a Disneyland would dare to be so brash.

Alexander the Great, wishing to flatter the Athenians (whom he had subdued), gave them golden shields to hang all round the Parthenon. This has always been regarded as an example of a typically military piece of bad taste. But in the small gallery of the British Museum, it is difficult not to believe that he understood the Athenians much better than we do. It has been calculated that they spent over six million pre-devaluation dollars in the mere decoration of their new civic structures. Art was, for them, not only business; it was promotional. The Parthenon was a hoarding on which everybody could see how the Athenians had come out top dog over their fellow Greeks.

With Alexander, art as a business began to benefit the artist himself. Apelles is generally considered, both by the ancients (who saw his paintings) and our art historians today (who unfortunately have not, because all his work is lost), as the father of the graphic arts of the Western World.

Apelles seems to have been born with great gifts, among them being a sense of the importance of money.

As a youth he studied under the master Pamphilius. In the fourth century B.C. education was one of the cheapest things available, teachers then, as now, being very poorly paid. Alexander, sensing not only a good investment but also what we would call good public relations, paid Pamphilius the huge sum of a talent for his instruction. It is difficult to say how much a talent was worth in those days, but it was certainly more than an ordinary laborer could earn in a lifetime—and teachers were not ordinarily paid much more than workmen.

His investment paid off. Apelles became official painter to Alexander the Great, and the heroically handsome portraits of that king with which we are familiar owe much to his genius. It was told of him that when he painted a bunch of grapes, birds flew in at the window and pecked at them. When Alexander, who would seem to have been one of those persons who know little about art but know what they like, criticized his painting of a horse, Apelles showed the picture to a real live horse. The horse neighed, at which Apelles told Alexander that the horse knew more about painting than he did. Apelles was obviously a dedicated realist, but we need not assume that he painted his royal master with all his defects. Alexander was an intensely vain man. Apelles was, in fact, the first fashionable portrait painter in history.

He was also adept at the mysteries of pricing a work of art, and he should be the patron saint of gallery owners. He adopted, or even invented, the same system that Picasso has described for us in the case of the auction of a Gauguin. Apelles was always generous in

the praise of his contemporaries. One of them was Protegenes, who had no business head at all. The citizens of his town were caviling at the price he was asking for a painting. Apelles bought it for the thundering sum of forty talents. If modern publicity methods apply in this antique instance, this fortune never actually changed hands. When asked why he had done this, Apelles said that he liked the picture so much he proposed to sign it and pass it off as his own work. He should therefore also be the patron saint of all forgers. At any rate, the trick worked: the awed citizens determined that, from sheer civic pride, they should not let so valuable a work slip through their fingers. They came to a satisfactory settlement with Protegenes and kept the picture in their town. Huge funds are raised from the public today by very much the same device.

It should be remembered that the greater part of the art production of the Greeks was what we call today municipal art. Statues were commissioned to commemorate local heroes, such as young men who were victorious in the Olympic Games. Since athletes, by the very nature of their excellence, have deformed muscles, the sculptors obligingly worked out a formula for the perfect human body, and it is these artificial constructs, pleasing to the eye of the subscribers, that today take our breath away by their beauty. Statues of gods and goddesses were painted to look as real and living as possible, because they drew bigger congregations of worshipers and hence bigger donations. The inhabitants of Cnidos refused to sell the statue of Venus by Praxiteles to King Nicodemus of Bythnia, even though he offered to pay

off their heavy civic debt. Praxiteles attracted the tourists, who would, in due course, adjust the balance of payments quite as well as Nicodemus.

Not until the Romans do we find art being prized because it was art, and even their motives were mixed.

146 B.C. is a crucial date in the history of the fine arts, because it was the year the Greeks conquered the Romans. That, at least, was how the Greeks were fond of putting it. In sober historical fact, it was the year in which the Romans finally subdued the Greeks and added the country to their empire. But, in epigrammatic terms, the Greeks, in spirit, "conquered their conquerors."

Before this, the Romans were rude, rustic, and proud of it. While they were building their empire by taking over the Italian peninsula, the virtues they admired were those of bullet-headed farmers who, in their belief, had founded the Roman state. Rome, in fact, had been started by a band of outlaws and rapscallions who had gathered together under the shelter of the Capitoline Hill and the adjacent Palatine, the area being a sanctuary for wrongdoers. They settled down into a community of farmers, herdsmen, and merchants, with a marketplace known later as the Forum. For a while, a neighboring tribe, the Etruscans, ruled them, but they soon developed a way of life very much their own.

A typical hero for them was the farmer Cincinnatus, who, called from his plow to lead the citizens in a boundary skirmish, won the battle and then went back to

his farm. (George Washington did the same thing, but in a much more grand way.) Cincinnatus had, or was believed to have had, the simple virtues of an actual tiller of the soil. These did not, of course, include an appreciation of the fine arts.

With the growth of Rome as a city, these virtues declined in practice but rose in the public estimation. We may take as a typical propagandist of this view Cato the Elder. He held firmly to the belief that the old ways were best. These included, for him, the right of the power of life and death over his sons, daughters, and wife. Slaves should be worked mercilessly until too old to be of use, when they should be abandoned. Fripperies of dress were anathema, and although Cato was partial to the sound of his own voice in the Senate he regarded both philosophical disputes and talk about art as effeminate and *Greek*. His own philosophy of life was of the cracker-barrel type, but to be fair to him he was not without a certain gruff humor. When he saw a youngster coming out of a brothel, he said, "Good. Good." But when he saw the same youngster coming out once again, he said, "I did not mean every day." One trembles to think what he would have said if he had seen him coming out of an artist's studio.

But Rome grew rich with the loot and tribute of empire. With riches came leisure—and an army of slaves to do the hard work. If a general in the later years of the Republic had imitated Cincinnatus and gone back to the plow, he would not have known one end of it from the other. With the conquest of Greece, and that part of southern Italy the Greeks had colonized long before

came the realization among the upper classes that the Romans were no more than highly successful louts compared with the people they ruled. A passion for things Greek swept all classes that had the money to indulge it. We are fortunate in having direct and intimate evidence of the mania.

Marcus Tullius Cicero was a man of many parts, one of which was, unhappily, his head. In 43 B.C. this was cut off on the orders of Mark Antony. Cicero has won immortal fame as a writer. A mastery of prose is not necessarily a hindrance in politics, as Disraeli, Churchill, and De Gaulle have shown, but in Cicero's case it was no help. In the power struggle that followed the assassination of Julius Caesar, Cicero backed Octavian (later Augustus) against Antony; a correct choice, as it turned out, for most people but Cicero. Octavian changed tactics and backed Mark Antony, and that was the end of Cicero.

Before that he had been seized with a passion for things Greek, particularly their sculpture. He collected avidly. He had a friend and agent, Atticus, whom he constantly importuned to buy more and more examples to decorate his villas, of which he had more than one. His enthusiasm is best expressed by himself.

Cicero to Atticus (67 B.C.); I have raised the 20,400 sesterces for L. Cincius for the statues of Megaric marble, as you advised me. Those figures of Hermes in Pentelic marble with bronze heads about which you wrote, I have already fallen in love with: so please send them and anything else that you think suits the place, and my enthusiasm for such things, and your own taste—the

more the merrier and the sooner the better—especially those you intend for the gymnasium and my own private cloister. For my appreciation of art treasures is so great that I am afraid people will laugh at me, though I expect encouragement from you.

It is natural to ask how much Cicero had raised for his statue in our own currency. It is a vexing question. The rulers of the ancient world were well aware of the advantages of clipping the coinage when they were short of funds and of debasing its metal content. It is possible to do sums allowing for this. Unfortunately, as soon as we arrive at a figure, *we* debase our own currency, so the sums have to be done all over again.

By a piece of good luck, which includes a volcanic eruption, we can arrive at the purchasing power of Cicero's sesterces. One of his villas was at Pompeii. That villa (in spite of what the guidebooks say) has not been discovered. But the Pompeians were fond of keeping accounts in the form of graffiti on their painted walls. These were discovered when Pompeii was dug up by the archeologists. We have a fair, if incomplete, notion of the cost of living in Cicero's day, or a few years beyond it.

With 20,400 sesterces, Cicero could have bought thirty-nine and a quarter mules. If he forwent buying another statue at the same price, he could have used the money to buy eight slaves to look after the mules and have some small change in pocket. Slaves need dressing and, by giving up another statue (which Cicero would have found painful), he could have bought a lifetime

wardrobe of no less than 1360 simple tunics for them. In a word, Cicero laid out a considerable sum of money. But he was more than happy to do so.

> *Cicero to Atticus:* I am waiting impatiently. My course is long enough. This is my little weakness. Please bestir yourself about it. . . .
>
> I give you a commission for two bas-reliefs for insertion in the wall and two well covers in bas-relief.

His enthusiasm, when the treasures arrive by boat, is breathless:

> The statues you have obtained for me have landed at Gaeta. I have not seen them yet, as I've not had time to get away from town; but I've sent a man to pay for the cartage. Many thanks for the trouble you have taken getting them—so cheaply, too.

The statues and carvings poured in from Greece, and finally Cicero had to answer the question that faces every collector—where is he going to put all the stuff?

> I am delighted at your news about the Hermathena. It is a most suitable ornament for my Academy, since no classroom is complete without a Hermes. The statues you sent me before I have not seen yet. They are at my house in Formia. I will have them all brought to my place at Tusculum, and if ever that gets too full, I'll begin decorating Gaeta.

Cicero had another problem, peculiar to his time and nation. He was a highly successful lawyer. His courtroom harangues were by far the best of the day. Now, if a successful lawyer of our own era showed us his

Matisse drawings, his Degas bronze, his Joan Miró oils, we would be impressed with his taste and envious of his fees. We would not consider him effeminate, frivolous, unreliable, or unpatriotic. But that is just what Romans of the school of Cato thought of the new craze for art—and they were in the great majority.

The result of this is a historical curiosity. We find a man of discrimination in the arts and an outstanding collector pretending publicly that he is no such thing to protect his professional reputation.

Cicero's speeches for the prosecution against the governor of Sicily, Verres, are classics in every sense of the word. After his first address to the court, the defending counsel advised his client to leave the country, which he did.

Verres was accused of a great number of crimes committed during his period as governor. These included extortion, outright robbery, peculation of every sort—and so forth. They were common enough offenses among provincial governors throughout Roman history. Verres, however, was also a collector of objets d'art. He acted on a grand scale, very much in the manner of Hermann Göring. What he wanted he took, stripping villas of everything of artistic value, altering owners' marks on them so that they looked as though they belonged to him, and, like the American millionaires of the nineteenth century, employing agents to spy out treasures. Cicero poured scorn on all this, and it might be held that to do so was all in a day's work for a famous trial lawyer. But he added an aside that shows how precarious the new taste for things artistic still was. He

professed not to know the name of one of Greece's most famous sculptors, Polycletus. Not only must he have been quite familiar with it—hc had spent three years in Greece, learning rhetoric—but even as he said it he must have dearly wished that Atticus would send him a Polycletan statue.

Mark Antony put an end to Cicero's collecting; he was executed while on his way in a litter to one of the villas he had so lovingly filled with beauty. Antony, a lover of beauty too, but in the more fleshly form of Cleopatra, came himself to a tragic end, and Octavian ruled supreme.

Under the name Augustus, given him by a grateful Senate, he brought peace to the world of Rome. It is a pity that Cicero did not live to see it, because with peace came unexampled prosperity, and with money came a taste for art, not merely among a select few connoisseurs who were afraid of being thought less than manly but also among everybody who had money and wanted to show it. The price of Greek originals soared. The laws of aesthetics were rapidly replaced by the laws of supply and demand. The paying public wanted statues and still more statues, and an industry was set up to supply them. Copies of Greek statues were made by the thousand. Some were good, most were fair, and many downright bad—botches put up to meet the demand. Two of the worst of these survived, above ground, through the centuries. They are the familiar group of two young

men holding back two horses that have a place of honor today outside the Quirinal Palace in Rome. The name of Phidias is carved on the base of one of them, that of Praxiteles on the other. Those names were carved on hundreds of other copies, for the art of faking had begun in earnest.

Whenever a taste for art becomes widespread, the true connoisseurs grow weary of liking what every successful moneybags proclaims he likes. They begin to look backward to the origins, and they collect pieces the others think too crude to buy. Thus when the Victorians were in ecstasies over Raphael and Guido Reni (to say nothing of *The Monarch of the Glen*), Prince Albert added to his unpopularity by buying wooden panels by Duccio and other Italian Primitives, as they were called. Some time before that William Beckford bought Bellini for a song while others were scrambling after Claude Lorraines. Beckford's and Albert's pictures are now the glory of London's National Gallery.

In much the same way, a taste for archaic Greek sculpture grew up in Rome. The stiff poses, the frozen smiles of these works would not appeal to the newly rich, who clearly wanted a statue of a woman to be curvaceous or a boy to look like a boy. The archaic artists were, nevertheless, superb artists within their formal limits— and much easier to copy than the works of their successors. Forgers of antique art flourished. Some of their productions have survived and, like the necklace of Tutankhamen's queen, have deceived the experts for years. Judgment still remains a ticklish matter. Some of

the fakers were clever enough to get their marble from Greek quarries.

Under Augustus, Rome teemed with sculptors, many of them immigrant Greeks. He himself boasted that he had found Rome brick and left it marble. He was a remarkable man, and the story of classical art owes much to his sagacity. Like many absolute rulers, he used art to glorify himself. The Greeks always sculpted their heroes in the nude, and naked statues of Augustus sprang up all over the Empire. It is interesting to note that Augustus himself was so sensitive to the cold that, according to Suetonius, he always wore woolen drawers.

Chapter 2

The Church
as Patron

It is well known that bad money drives out good. So does bad art. After the magnificent achievements of the Augustan age, a steady decline took place all over the Roman Empire. We are accustomed to blame such descents on the lack of good artists. But it is probably more accurate to say that when the public is willing to pay money for poor work, there is no incentive for the artist to do his best. Landseer's bronze lions in London's Trafalgar Square are approximate in design and feeble in execution. But they were just what the Victorian public wanted, and it made their favorite artists rich men.

The notion of setting up a large column, such as
that erected for Nelson, came from Imperial Rome.
Two such columns have survived, those of Trajan and
Marcus Aurelius. A spiral band of reliefs winds up both
of them, portraying scenes of battles and siege. Once,
during the restoration of one of them, I was allowed to
climb up the workmen's ladder to the top. It was a long
climb and a dizzy one, and if I did not get vertigo, it was
because I was continually marveling at how bad were the
sculptors who had worked on it. Subsequently, I studied
the casts of the other column, that of Trajan, and that
was no better.

It might be imagined that poor work passed muster
because the reliefs were above eye level. That excuse
cannot be accepted because, in the case of Trajan's
column, a library surrounded it on three sides, and it
could be examined from the upper floors. The Romans
simply did not think it was a botched job. They liked it—
so much so that when Trajan died they placed the urn
with his ashes in the base. The arch of Septimius
Severus, made about a century later, is even worse.
When it came to Constantine, in the last days of Rome as
the imperial capital, the artists were so lackadaisical that
they robbed earlier monuments to finish it. As for the
colossal statue of the emperor himself, incompetence
plumbs the depths.

Evelyn Waugh, in his novel *Helena*, waspishly makes
the artists insist that theirs was the contemporary taste,
and the emperor could take it or leave it. Waugh did not
like the artists of his own time. Bernard Berenson was
not sure whether he liked them or not, but perhaps

thought it professionally wiser not to make enemies. But even he, surveying the same arch, wonders how artists could be so bad and speculates, cautiously, whether sculpture does not have its periods of inevitable decline.

We can be more fair to the artists than either Waugh or Berenson. Excellent artists were there, if they were wanted. Hadrian, who insisted on his good taste both in art and boys to the point of thrusting it down the public's throat, managed to have some passably good statues of his favorite Antinous made for distribution throughout the Empire. The bust of Commodus as Hercules was done by a sculptor in command of his craft: Commodus, who was passionately fond of fighting in the arena, probably did have the vacant look the artist has given him, since it is often found in those devoted to physical exercise.

Such artists, however, were not particularly wanted. Money was paid for copies, and copies of copies, of the masterpieces of Greek art. If Cicero was impatient to see his originals, his successors (with even deeper purses) were impatient to have their new villas crammed with statues and paintings. The frescoes of Pompeii and Herculaneum show every sign of being done slapdash, much like the paintings of the walls of newly built offices of today's multinational corporations. When commissions go to those who can supply a lot and quickly, the artist cannot be blamed for reasoning that it is proper to hack. Besides, some of the reasons he can find (or critics can find for him) are satisfactorily high-flying.

In A.D. 312 Constantine legalized the Christian religion, an event that was to have a devastating effect both on the liberty of the artist and on his income.

Constantine's motive was political. The civil servants upon whom he relied to run his Empire were increasingly converted to Christianity; so were the soldiers he needed to defend it. In the first case, it was reasonable that civil servants should follow Jesus, for the Nazarene was one of the few people who have ever had a good word to say about taxgatherers. The case of the soldiery is more obscure, as obscure as the religion of Constantine himself. We know that he reverenced the relics of the Passion: he had two nails from the True Cross made into a bit for his horse. But he remained a pagan to the hour of his death, when he professed Christianity with his dying breath, at least to the satisfaction of the priests who invaded his bedchamber.

Whether he knew it or not, Constantine had started a revolution and it was one that boded no good for artists.

With the Christian revolution (as we may call it) vast sums of money came into the hands of men who were unaccustomed to handling it, and who, in many cases, had taken vows to ignore the evil stuff completely. These were the thousands of bishops, abbots, and monks. The imperial court showered gold upon those who met with their approval. Rich men, conscious of their sins, left fortunes for priests to pray for the safety of their souls in an afterlife that had suddenly become a very real menace.

With money came a sense of power. The only people who could tell a bishop he was wrong were the

emperor or his fellow bishops. In that case, a theological brawl would break out that might lead to bloodshed in the streets or banishment to the frontiers. But for an ordinary man such as an artist, the bishop's or the abbot's word was law. It is not an exaggeration to say that an artist in Byzantium was in much the position of an artist serving a modern advertising agency. He must put across the client's message. He will be praised if the client is pleased and fired if the client is not.

The message was, of course, Christianity. Churches were needed in a hurry, since it was unthinkable that the worshipers should gather in a pagan temple. Nobody knew what a Christian church should look like. Gatherings hitherto had taken place in private houses. Perhaps, under some aesthete such as Hadrian, a great efflorescence in architecture could have taken place, with new plans and new designs. The bishops would have none of it. They paid architects to run up imitations of the most banal form of classical architecture, the law courts, or, as they were called, basilicas. A basilica consisted of a large rectangular hall with an apse or a raised platform at the end for the judges. Constantine's first church, St. Peter's at Rome, was built after this design, as were the churches of the Nativity in Bethlehem, the Holy Sepulchre, and St. Paul's Without the Walls in Rome. All these have been greatly altered (the original St. Peter's being totally destroyed), but in the basilicas at Pompeii and Leptis Magna we have some good examples of the design.

As for the decoration of these bare structures, the bishops at first opted for none at all. The first-century

Council of Elvira banned paintings altogether. Eusebius, the first historian of the Church, was asked by Constantine's sister to send her a picture of Christ. Eusebius wrote her a letter refusing to do so on the grounds that making pictures of gods was the sort of thing the pagans did, and that now, fortunately, those debased times were past.

Had this taste lasted, the artist might well have disappeared from the Empire, as he did during the Puritan Revolution in England. The bare meeting places of some Christian sects in America, Europe, and elsewhere are an attempt to get back to this original simplicity, as indeed are the stripped altars ordered by the Second Vatican Council in our own time.

Deprived of money by the religious establishment, the Byzantine artist could not retaliate by turning his back on the Church and working for some private patron. The patron, at the peril of his immortal soul, could not disagree with the bishop. He might well express some individual taste in such things as jewelry for his wife and fine brocades to wear. When it came to pictures or statues or even illustrated books, he would carefully conform. So did the court of the emperor. The emperor himself was gorgeously robed, as were the bishops and priests. There was money to be had in that direction, and plenty of it. But to earn it, the artist had to turn into a dress designer.

The purse strings of the bishops might never have been loosened for the artist if it had not been for a dispute that inevitably, today, we must consider curious, because it concerns theology. This is a study fascinating

to other theologians but rarely to anybody else, however devout. But in those days a theological argument could set the whole Empire on its ear, much as Mao Tse-tung upset the Communist apple cart for the Russians.

God could not be portrayed, so Christ could not be pictured—because he was God. Or *was* he? Jesus was undoubtedly a man who was born, lived, and died in a small area of Asia Minor. This was the foundation of the now-triumphant faith. But one or two ecclesiastics in Alexandria with a bent for philosophical disputation argued that a *man* could not be God, or, to be less sweeping, Jesus was God only in a very limited way. Apparently without any fervid desire to do so, Arius became leader of this school of thought, which spread rapidly. Arianism did great harm to the unity of the Church, but it was, indirectly, a boon to artists. After a prolonged debate, which often broke into uproar, the official creed of the Church was laid down in the Council of Nicaea: Jesus was part—and at the same time, the whole—of the Holy Trinity, which consisted of God, Man, and the Holy Spirit. This doctrine, though satisfactory to the bishops, was admittedly subtle. It was seen that it could easily escape the common man's understanding. It was therefore urgent to put before his very eyes a representation that would show Christ as plainly man yet awesomely God.

Something had to be done. Books were no use, because most of the worshipers were barely literate. Sermons were tried; but although the congregation could not read, it could sleep. There was nothing for it

but to call back the artist. He came, but it was not in any sense as a creative person.

In one way the artist was even more restricted than his modern counterpart in Madison Avenue. He was forbidden all recourse to sexual attraction. The nude totally disappeared from art: the allure of a beautiful male or female body was forbidden. Sex vanished from art as suddenly as teenagers have disappeared from cigarette advertisements. The reasoning was parallel. Smoking, say the doctors in our own time, is bad for the health and should not be encouraged. Sex, said the bishops, was bad for the soul and should only be encouraged when used to make more Christians. We can, and do, argue with the doctors, but every good Christian agreed with the bishops. For three centuries the Christians had writhed under the propaganda of the pagans, who had accused them of indulging in sexual orgies during their rituals. They had denied it hotly.* They had, in fact, led unusually chaste lives.

But chastity, as the later Puritans knew, to be effective must be advertised, which is why they adopted their peculiar form of dress. The Byzantine artist, to earn his bread, had to abolish the human body, the mainstay of his profession until then. He obeyed by

* Another cause of the marked Christian aversion for the human body was that the pagans accused them of cannibalism, particularly of eating babies. This was supposed to be an appetizer for the subsequent sexual rites, which were largely incestuous. Tertullian, the Christian apologist, ingeniously points out that pagans ate babies of the coming generation when they committed fellatio. Christians notoriously did not do this, further evidence of their chaste behavior.

swathing it in voluminous clothing from which bare flesh emerged only in the shape of a face, the hands, and in very exceptional cases (such as known anchorites and hermits) the feet. Beauty parlors, under the pressure of manufacturers of cosmetics, have today reduced women's faces to a formula. Under the pressure of the Church's money, Byzantine artists reduced the infinite complexities on the folds of clothing to a set of easy-to-copy rules.

It is convenient to study this revolution in the famous mosaics at Ravenna, Italy.

We begin with money. A banker, Julian Argentarius, was a man well acquainted with the corridors of power in the court of Byzantium. He was a confidant of the emperor, who employed him on special and secret missions. One of these was to prepare for the taking of the town of Ravenna, in northern Italy, which was in the hands of the Visigoths. They had poured across the frontiers of the Empire and set up their own state. They had been Christianized but had adopted the Arian heresy instead of the Trintarian faith, though we may charitably assume that they understood neither very well. They were obviously ripe for expulsion by the orthodox, and the Emperor Justinian had a general who was competent to do it, Belisarius. Argentarius worked his wiles, Ravenna fell, and the heretics were expelled.

But the original citizens remained. The problem was how to bring home to them their glorious good

fortune in no longer being in the thrall of heretic barbarians. They were now subjects of the all-powerful emperor in far-off Byzantium, dispenser of all good things to his people. Besides, they also had the inestimable privilege of being under a bishop of the true faith, the only one acceptable to the God who was Three-in-One. The memory of the Visigoths had to be extirpated from their minds.

In our own day, this is called among Communist states re-education, and it is cheap. All that is needed is a teacher and some textbooks and perhaps some physical persuasion that also does not cost the taxpayer much money. There are also processions with banners.

The Church in Ravenna had no reason to be parsimonious. Argentarius had money to burn, and the Church ordered what must be the most expensive banners in history, and certainly the most enduring. In A.D. 522 he rebuilt the natives' own church, San Vitale. He summoned artists and ordered mosaics for the walls. Two of these mosaics are the best-known (and least restored) specimens of Byzantine art.

One shows the emperor with his court. All the figures are hidden, as required, in long, stiff draperies. The faces show an immense—and almost Buddhist—calm. The mosaics still produce a sense of awe in visitors; we can see that it was quite reasonable, when approaching such superhuman figures in real life, to bow to the ground three times as etiquette required when one went to court. The artists have earned their pay. The first part of the message still comes across.

The second part of the message was more practical.

The Church taught that it is more blessed to give than to receive. Therefore the emperor is shown giving gifts, and, as a lesson to the people of Ravenna, he is giving them to the bishop. And here as in our own days of advertising, the message gets the better of good taste. Scrawled over the bishop's head, in large black characters stridently in contrast with the design, is his name, MAXIMIAMUS.

Another mosaic, equally large, shows the Empress Theodora and her attendants. Theodora was a remarkably able woman. She brought to her role as the consort of Justinian the same application with which she had conducted her previous profession, prostitution. She once said that her only regret in that period of her life was that there were only seven openings to the body (as Gibbon, in a Latin footnote, records for us). Not a touch of that is allowed by the artists to appear in the mosaic, although they must have known the story. She is not only portrayed as being pure: she is so pure as to be scarcely a woman.

The men who made these mosaics were undoubtedly accomplished artists. What is interesting is that they entirely suppressed their own personalities. They followed the rules laid down for them, did their job, and took their fee. Yet these two mosaics are unsurpassed, of their kind, in all subsequent ages.

Should we have any lingering doubts about their being advertisements, we have only to look at the Christ in another, smaller church. We have seen that the Arians disagreed with the orthodox about the nature of the divinity of Christ. Lest anyone should still cling to

their heresies, Christ holds an open book in his hand. On one page is written *Qui vidit me vidit et patrem* (Who sees me sees the Father) and on the other page the message has even more punch: *Ego et pater unum sumus* (I and the Father are one).

It does not matter that most of the congregation could not read. The Church had reduced the propaganda to the simplest formula, and this, repeated a few times by the priest, was as good as an advertising jingle is today. Possibly the only organizations of our own time that can dispose of as much money as the early Church in advertising are the sellers of gasoline and soft drinks. The owners of Coca-Cola are well aware that for decades illiterate masses all over the world, quite unable to read a letter of any language, see the shape of their signs and duly buy a bottle.

Throughout the Dark Ages and the early Middle Ages the Church put up the money for such artists who would do what it wanted. I am not concerned here with an aesthetic judgment of the value of the art produced. Let that remain a matter of taste, which has varied greatly in its verdicts over the ages, from the contempt for Gothic of the eighteenth century to our eclectic admiration for all its phases. I wish now to turn to a closer examination of the money the Church disposed of to promote that artistic output. The facts become clearer if we confine ourselves to Western Europe, where the vast majority of those works are to be found.

When the horrors and devastations of the barbarian invasions had passed, the Church emerged as the one institution in Western Europe that had any money at all. The landowning nobility consumed their substance in continuous petty wars to protect its property. Trade was at a standstill, since the Roman roads were in ruins and the seas infested with pirates. By the tenth century, the western Mediterranean had become a Moslem lake, dominated by the new and warlike religion of Mohammed.

In the midst of all this confusion, the Church was indeed the rock on which Jesus had predicted it would be founded, in the person of the fisherman-disciple Peter. It had acquired an enormous amount of real estate, denoted by the faithful on their deathbeds. The monastic orders had created even more. The Benedictines, surveying the wastelands that the incessant invasions had produced, sensibly said that to work was to pray and reclaimed vast territories from the wilderness. At a time when there was no escape from the squalor and filth of life (even in the insanitary castles of the nobles) except in the ceremonies of the Church, the priesthood had acquired a great treasure of gold and silver and jewels. The Body and Blood of Jesus being exposed daily on the altar had to be given a setting for its tremendous significance in a time when terrestrial hopes were continually frustrated and confounded. This meant gold, and it was forthcoming.

The Church acquired its wealth very much as the great insurance companies of today acquire theirs. Gifts to the Church insured avoidance of Hell. It also secured

peace on earth among the population. Western Europe
had become a largely rural economy, with the tillers of
the soil bound to the owners by a series of obligations—
to give them a part of the proceeds of their labors, to
bear arms when called upon, and to work for nothing at
stated times for their lords and masters. This we popu-
larly know nowadays as the feudal system, but there was
in fact no system, no dream of an ordered society. The
peasant was liable to be subjected to outrageous exploi-
tation, and he sometimes adjusted matters by rising in
revolt. The Church, basing itself on the Gospel teaching
that servants should obey their masters, sanctified the
feudal arrangements. Occasionally some enraged peas-
ant leader would question whether the feudal "system"
was really the will of God. As John Ball said, "When
Adam delved and Eve span— Who was then the gentle-
man?" But the Church could and did point out that
these two persons were scarcely good examples of how
to bow to the Divine Will. The nobles maintained the
Church for the same reason that we taxpayers maintain
a police force.

There was another reason for the Church's accu-
mulating wealth. The nobles often went broke. Wars
cost money; bad harvests were a disaster. The Church
stepped in with loans to keep the castle going, or money
to buy seeds to start a new crop, or even, when famine
stalked the land, to provide food to keep everybody just
alive. As well as a police force without club-swinging it
was also a Public Assistance Authority in times of trou-
ble.

But—and this is the master stroke of business

acumen—the Church arranged that, in money matters, it had no rivals. It declared flatly that to lend money at interest was a sin. It based this rule on texts from the Old Testament,* and it roundly condemned as a usurer and a sinner anybody who took profit from a loan. It is a sentiment with which everybody who has negotiated an overdraft must feel at least a passing twinge of agreement; but of course, money is never lent nowadays without interest. The Church however did this, and thus killed two birds with one stone. It put the moneylenders out of business and attracted even more wealth to itself. To curry favor with a bishop was as important then as doing the same with a bank manager is today.

The monopoly was not watertight. The Jews, who had also read the Bible, pointed out that Deuteronomy forbade the Jews to lend money at interest only when the borrower was another Jew: they could lend it to strangers and foreigners. They proceeded to do so, and the only answer to this piece of textual criticism was an

* Of these Biblical texts, the principal one is that of Ezekiel, who classes usurers with the fathers of thieves, worshipers of idols, adulterers, and committers of unspecified abominations—probably ritual sodomy with male temple prostitutes, a Canaanite practice. (Ezk. 18:8–17)

Other texts are Exodus 22:25; Deuteronomy 23:19–20; Leviticus 25:26; Psalms 15:5; Nehemiah 5. Nehemiah includes mortgages in his definition of the sin of taking usury (or interest).

It should be noted that the English translation of these passages is disputed. The Hebrew work *Neshek* may mean simply "interest" in a modern meaning of that word, and not excessive interest, which is our dictionary definition of usury.

Maimonides, interpreting Deut. 23:20, maintained that when a Jew lent to a Gentile he *must* charge interest, but this was strongly criticized by other Hebrew scholars.

occasional pogrom. There was also a black market among the Christians themselves in which the debtor acknowledged that he owed more money than he had actually received and duly paid the padded account, or the lender took a sum of money as security against the loan not being repaid and quietly pocketed the extra sum when it was. But up to the fourteenth century, the Church was Europe's banker.

It is to this that we owe the great Gothic cathedrals with which Western Europe is dotted. Yet one thing should be noticed. It was Thomas à Becket who was the rich man, and not the artist who built the cathedral in which he was murdered. William of Sens was ranked, and paid, no higher than an experienced artisan. Nor would the artist come into his own financially until the usurers came into *their* own. It was the moneylenders who started the revival of the artist as an artist that we know as the Renaissance.

Chapter 3

The Artist Regains His Freedom

I shall now tell of the way the artist, with the coming of the Renaissance, liberated himself and became the independent person we see today. But since the word *Renaissance* calls up pictures of such giants of egotism as Michelangelo, I must hasten to say that the liberation was not at all a dramatic affair: there was no defiant Prometheus or romantic rebel. In fact, the first man of art on record to use the word *freedom* about himself, Jacopo della Quercia, was a hesitant, haphazard, and unreliable person, always apologizing to his patrons. The freeing of the artist was not due to character, it was due to money.

To understand this we must know the conditions under which the medieval artist worked, right up to the fourteenth century. He lived, essentially, in a town, where he was a member of an association. This was the case all over Europe. The name of this association varied. In Germany it was *Amt, Innug, Zunft,* or *Handwerk;* in French it was *métier,* in English craft guild, and in Italian *arte.*

The origins of these guilds or corporations is obscure. They may have been survivals of the Roman *collegia,* organizations of craftsmen that Shakespeare's Coriolanus bereates for not bearing the tools and signs of their profession, but the connection is difficult to trace. In all probability they grew out of the human desire for security and protection. Whatever their origin, they grew to be very powerful. They established what we call today a closed shop. No artisan could work in a town unless he was a member of his guild, and he could not become a member unless the guild agreed to have him. Usually he would join as an apprentice. When his workmanship came up to the required standard he could become a full member and finally rise to be a master. He would then not only be a master of his craft, he would be the master, in another sense, of all those working under him. His word was law.

The guild fixed the price of the object that was manufactured, and all members had to observe it. Competition of any sort was rigidly forbidden. A goldsmith, for instance, who made better finger rings or brooches or saltcellars than anybody else was not allowed to charge more for his work. Nor was he encour-

aged to excel over his fellow craftsmen. The standards of workmanship expected of members were minutely specified by the guild, and the product regularly inspected. That was all that was required. A Benvenuto Cellini would have been considered a thorough nuisance.

Now the artist, whether he was a painter or sculptor or engraver, was firmly held to be a craftsman, on the level of other craftsmen such as woolworkers or metalworkers or the makers of furniture. To the contemporary lover of art this may seem shocking, but for really good practicing artists, the term has always had a certain allure. I remember Henry Moore telling me that when tiresome people asked him to explain his sculptures he would answer, "I'm a stonemason—and a damned good stonemason." However, Henry Moore would be greatly put out if some trade union forbade him to charge £40,000 for his latest work.

This is what happened to the medieval artist. As a craftsman, he had to join a guild. Guild members were not allowed to get rich. A very rich craftsman would obviously be in competition with the other members, and thus a menace. Even if the artist rose to be a master he would still be under this restraint. If a master obtained money from an outside source, such as an inheritance, he was not allowed to use it to expand his business.

But a subtle change was coming over the manners and customs of Europe. Hitherto the good life was, as the Church taught, something to be expected beyond the grave. Here below was a vale of tears. But Christians

became slowly aware that there were human beings who were having a glorious time here on earth—and these mortals were not Christians at all. They were Moslems. They had swept out of Medina and conquered an empire. They too believed in Paradise, where houris solved the eternal problems of sex by changing into any shape, male or female, that the fortunate Moslem desired. But the Arabs did not wait for felicity. They had it here below. They built luxurious palaces (of which the Alhambra in Spain is an example) and in these they lived a life of splendor and comfort beyond the wildest dreams of the Christians. Their clothes were finer, their food more succulent and diverse, their jewelry was fabled. The Crusades were meant to put an end to all this conspicuous expenditure. Instead, the Crusaders came back with a taste for high living.

This meant being able to buy exotic things that the narrowminded guilds could not supply. The Church had forbidden usury; it could not stop trade. While guilds held the towns in an iron grip, trade fairs outside their jurisdiction began to flourish. This was particularly so in the Champagne region of France. Here, in various centers, there were fairs which, by staggering the dates, lasted all the year round. Merchants from all over Europe gathered there, bringing with them the products of Asia—fine silks, jewels, and spices the Venetians had imported. With them came as well products of the artisans of Italy, made especially to satisfy this new taste. The guilds reluctantly had to recognize that there were other corporations of workers who thrived on what we now call foreign trade.

All this might have meant little to the artist (the Moslem artist was even less free than his Christian counterpart, since he could not represent the human form at all) if it had not been for a remarkable development of the money market.

Since it was both difficult and foolish to cart large quantities of coin across Europe, the merchants invented the letter of credit. Goods sent from, say, Lombardy to the fairs in Champagne could be bought for a simple piece of paper that would be honored on sight by the buyer's agent in Italy. This needed excellent accounting to balance the books. The Lombards became so good at this that the popes employed them to keep check on the vast sums of money that poured into Rome and, later, when the popes temporarily moved house, into Avignon. Lombard Street, the banking center of London, is a reminder of this revolution and where it came from. The Italians soon became Europe's principal bankers, although it should be noted that there were as yet no actual banks dealing solely in money. The "bankers" were essentially merchants.

They rapidly became immensely rich merchants, richer even than monarchs, who were constantly in need of money that they could not screw out of reluctant barons. Money was also needed to pay the ransoms of Crusaders and others who got themselves caught by the Arabs. The merchants lent it. One such merchant was a prime factor in changing the status of the artist forever.

He was Cosimo de' Medici (1389–1464). He was a merchant, pure and simple, entirely without the glamour or the culture of his descendants. But he under-

stood the power of money. So did the Signoria of Florence, which was sufficiently afraid of his growing influence in the city to exile him. He went to Venice, where he lived in a princely style and lent the Venetians money for a war in which they were engaged.

As for the Church, it too had learned the value of a quick supply of cash in time of need and began to turn a blind eye to the admonitions of the Bible about interest. Among the people to whom Cosimo lent money was Tomaso di Sarzana—an excellent investment, because he became Pope Nicholas V. But he scarcely needed such high-placed friends in the Church. Among the other notabilities who borrowed from Cosimo were the Duke of Burgundy and the King of England. In fact, the House of Medici was in its way as powerful as any of these people. The contemporary French historian Commyns waxes ecstatic about all that money: he calls it *"la plus grande maison que je croy que jamais ait éste au monde."*

The guilds survived the change to a money economy as they have survived in the shape of trade unions today, but they were no longer the only source of an artist's income. Cosimo, for all his wealth, had no social background. Although the Church could no longer enforce the ban on usury (even a British bishop borrowed money) Cosimo still had the stigma of being a moneylender. It was necessary for his pride to surround himself with the appurtenances of the landed gentry and the nobility. He had to have a court, however small, a palace, and some eye-catching splendor. He had little taste in art. (That came with the later Medicis; Giovanni, who founded the house, had no pretentions whatever.

Cosimo was Giovanni's son and Cosimo's grandson was Lorenzo the Magnificent. As the English say, it takes three generations to make a gentleman.) Cosimo had, however, a lively sense of what was going on around him among his intellectual superiors, as, indeed, have many successful moneyspinners today.

The Turks, the successors to the Arabs and of the same faith, were threatening Constantinople. The Orthodox Greeks there, seeking friends, made an effort to come to terms with the Roman Church, and there were high hopes that the long-standing breach could be healed. A council was held at Florence in 1439. It had no effect on the history of the two churches, but it was crucial for the history of art.

The Greeks brought with them the classical Greek culture of which they were the inheritors. To the Italians the Greek language was, as we say, Greek to them, but an enormous enthusiasm swept the elite of Florence to learn it. Although nobody could read Plato with any ease, a cultivated man would keep a bust of him in his library, in one instance even burning candles in front of it.

Cosimo was, of course, much too busy to learn Greek, but he surrounded himself with the visitors and joined in the discussions. His contributions were no doubt not very profound, but a man with that much money is always listened to. Besides, he took a much more practical step to join the new fashion. The son of his doctor, Marsilio Ficino, showed signs of being a brilliant scholar. Cosimo became his patron, and Ficino,

having mastered Greek, swiftly rose to be the leading philosopher of Florence.

He invented a philosophy of his own. Its importance to us is that it drew heavily on Plato. When Plato designed his ideal Republic, the chosen few who were to be its leaders were to take instruction in philosophy, mathematics, science—and art. Thus artists were, for the first time since the fall of the Roman Empire, spoken of with respect. The names that were passed to and fro were indeed those of the long dead—Phidias, Praxiteles, Apelles. But Apelles had talked back to Alexander the Great and, besides, had been handsomely paid.

Nobody, of course, thought that living artists (the artisans) could possibly be as good as the Greeks. But "Greek" statues were lying about all over Italy, and men began to dig them up. They were mostly those Roman copies that were made for rich men's villas, and some were not very good. Florentine sculptors, looking at them, wondered if they could not do as well, or even better, and perhaps earn rewards comparable to those of their Greek foreruners. Artists, those still rough men in rough clothes, became a fashionable topic of conversation. Cosimo's money had brought up Ficino; Ficino had explained Plato; to Plato the artist was an essential part of the state. The Renaissance had begun, and Cosimo's money was to play a further part in it.

But the change in the status of the artist, if encouraged by the merchants to help them climb the social ladder, was slow. It was resisted by the Church, which continued for as long as it could to regard them as

artisans. I can best illustrate this by describing the experiences of two artists, one still in the toils of the Middle Ages but determined to break free, the other Donatello, perhaps the first artist to be recognized as one of a new and important species.

Jacopo della Quercia was born in 1370. He was thus sixteen years younger than Donatello and nineteen years younger than Cosimo de' Medici. They were significant years for artists.

His work is not, perhaps, as well known today as that of the other Italian masters, but there can be no doubt of his great gifts. John Ruskin was not an easy man to please in matters of art: in his *Stones of Venice* he completely loses his temper over church façades he does not like. But Jacopo sent him into such ecstasies that I shall quote him. Poor Jacopo, after all, never had such warm things said about him in his lifetime.

One of his masterpieces is the tomb of Ilaria del Caretto in the cathedral at Lucca. Her figure lies on the top of the rectangular block of the tomb, in the medieval fashion. Ruskin first saw it in 1845. "From that day I left the upholsterer's business in art to those who trade in it," he wrote. "I began my true study of Italian and all other art here beside the statue of Ilaria di [*sic*] Caretto, recumbent on her tomb." He gets his Italian wrong, perhaps excusably, but there is no doubt about his contempt for people who worked for mere money— "those who *trade* in it." What knocked Ruskin as flat as Ilaria on her monument? There can be no better words than his own:

You are to note that with all the certain rightness of the material fact this sculpture is still the sculpture of a dream. Those straight folds, straightly laid as a snow-drift, are impossible—known by the Master to be so—chiselled with a hand as steady as an iron beam, and as true as a ray of light, in defiance of your law of gravity on earth.

So much for Isaac Newton. The contemporary visitor to the tomb may be struck by the resemblance in looks and that straight-down dress to the Pre-Raphaelite women who so took Ruskin's fancy. Nevertheless, Ruskin's eye was true even at the young age of twenty-six. Jacopo was undoubtedly an original man. One has only to see his version of God creating Adam on the Porta Magna of San Petronio at Bologna to feel, as do many historians, that Michelangelo must have seen it and remembered it when he was up in the ceiling of the Sistine Chapel.

But I am concerned here more with Ruskin's vision of the spirit of the sculptor exalted above mere trade and even the law of gravity. The fact is that Jacopo was very keen on money and, according to his contemporaries, none too straightforward in dealing with it.

We have the contract the clergy of San Pietrino gave him for work on a doorway. He was to carve statues of the prophets. For this he was to receive 5600 gold florins, specifically those issued by the pope. This looks generous, but the trouble came with the advance. This was to be merely 150 florins. With this small sum Jacopo would have to buy the stone, pay for its transport, buy

the wood for a scaffolding, and pay his assistants. Throughout his career, this business always troubled him. He would spend the advance and then, to cover his ongoing expenses, he would take on other work in another city, leaving the first job unfinished.

The clergy were well aware of this habit among artisans. Therefore we read that as a precaution and "to secure [Jacopo della Quercia] keeps his promise," a Maestro Thomasino da Bressa undertakes to pay back part of the advance, as guarantor, every time Jacopo does not turn up to work. Thus the guild, through the master, is made responsible for the delinquencies of the workman.

The contract goes on to say that Jacopo will be paid each month the money that he has earned, thus reducing him still further in his status. He is not even a wage earner: he is a piece worker. The sculptures must be finished in two years, and the contract includes Jacopo's promise that this will be so. The two years, says the contract, with remarkable nitpicking, will be counted from the day he gets the stone and *begins work on it*. This clause is pure arrogance. Jacopo could easily knock a chip or two off the block in his studio and then put his feet up. The clergy had absolutely no means of knowing whether he was really at work or not. Perhaps Messer Thomasino da Bressa would drop in to see if his guarantee was safe. Perhaps the clergy were just being rude.

The last clause certainly is. It says that "everything must be done as in the design, but with more perfection than the design shows." In other words, Jacopo, in the

immemorial words of schoolteachers, is good but Could Do Better.

Yet let us look a little closer at that yellowing manuscript with its crabbed handwriting. Jacopo, to get the commission, had obviously done some sketches. Now, he was sufficiently gifted with original genius to precede Michelangelo himself in interpreting the creation of Adam. Having given the clergy these sketches for free, he had trapped himself into signing any contract they chose to push onto him. If he refused, his ideas could simply be plagiarized by another—and cheaper— artist. There is no suggestion in a single line of the contract that what the clergy wanted was the work of one of the most talented artists of the day. They did, but they would not say so.

From a host of similar documents that have survived in church and cathedral archives and the Vatican Library, it is clear that most artist-artisans signed such agreements without demur. Jacopo was made of different metal. He saw that nobody could really force a genuinely gifted artist to turn out his best work if he did not feel in the mood to do it. He was much in demand because he was so good. He therefore set up the practice of signing the contracts and then driving a coach and horses through its clauses. He would agree to begin work, begin it, then accept the rival commission. This was no doubt bad for his guarantors, but it was excellent for Jacopo.

This constantly enraged the clergy, who looked back on the old days when the artisan-artist did his job and touched his forelock when he was handed his

monthly florins. Siena engaged him to work on the baptismal font in its new cathedral. Jacopo, as usual, took up other work, in Bologna. Siena then promptly threatened him with a fine if he did not return in ten days (August 26, 1428). Jacopo returned, but the Concistoro, overreaching itself, ordered him not to leave the city without permission. Two years before he had been sued for the return of an advance payment (February 1426) because he had not felt like doing the two reliefs that had been contracted for. All this uproar could only mean one thing. Jacopo was an outstanding artist, a man in his own right, and no longer an artisan. Jacopo, in the end, never did the reliefs.

He sometimes returned the advances when a more profitable contract enabled him to do so. It was on one such occasion that he wrote saying that he gave back the money, not from any sense of being in the wrong, but because he wanted to feel a free man. It is the first breath of the wind that was to blow through the world of the artist and his new sponsors, the men who had thought up the letter of credit.

It is interesting to compare Ruskin's vision of Jacopo's way of working with the way he actually went about his art. For Ruskin, he was the inspired sculptor, conceiving his masterpieces on an almost transcendental level, aiming to communicate an experience beyond mere stone to the sensitive observer. This is the high opinion Ruskin had of artists who impressed him. He was convinced that art was not true art unless it had moral elevation. He was disgusted with certain baroque

façades in Venice because he felt that they lacked this essential quality.

There was a newly rich family in Lucca. They decided they were wealthy enough to have a chapel of their own in Lucca Cathedral, the church in which Ruskin had his change of life. They engaged Jacopo to do the sculpture. This time there would seem to have been no money troubles. All the same, Jacopo got himself into hot water. He worked, as was the custom, behind a screen, and no doubt he concentrated on what he was being paid to do. But apparently Jacopo decided one day that all work and no play was making Jacopo a dull boy. So in 1413 we find him accused of theft, rape, and sodomy with his young male assistant Giovanni di Imola, all behind the screen in the cathedral. The woman in the rape charge was a merchant's wife.

Ruskin was not much given to poring over old documents—with his splendid prose style, he did not have to—so I assume he did not know of this escapade. I suppose he would have been shocked at something so morally far below what he thought an artist should be. On the other hand, he might have felt just a twinge of envy, especially about the merchant's wife. Ruskin's great burden, besides the baroque, was that he was impotent.

The reliefs for Siena that Jacopo did not do were given to Donato di Nicolo di Betto Bardi, known to the ages as Donatello (1386–1466). Born in Florence in far from fortunate circumstances—his father was twice exiled and also condemned to be beheaded and his carcass

to be drawn by a donkey—Donatello, his father fortunately reprieved, turned goldsmith and worked for that guild.

But he went to Rome and there saw the sculptures that followers of the new fashion for the classical were unearthing in quantity. He admired them tremendously, as did everybody, but he decided that he could sculpt just as well.

The time was ripe. The line between artisan and artist had to be crossed, and Donatello did so in a spectacular manner. From documents dated November 23, 1406, when Donatello was thirty-four years old, we learn that he was engaged for an advance of ten gold florins for statues of prophets to be put on the Porta della Mandorla. He completed one, and so struck was everybody with his skill that he got a raise in pay: he was given sixteen florins for the one statue. Three days later his *David* was commissioned. The world has marveled at it ever since, but its history is a vivid indication of the uncertain taste of the times. It was put in a cellar and not taken out till July 1416, and only then at the urgent request of the Priori of the Signoria. Somebody clearly had not liked the elegant bronze boy, because Donatello had not been paid the five gold florins that had been named as its price.

By this time Donatello was one of the artists with whom Cosimo surrounded himself. It does not seem that Donatello was much of a courtier. Cosimo sent him a rich suit in which to present himself. Donatello wore it twice, then sent it back, saying it was too delicate for a person like himself to wear. It was an equivocal remark.

Had he really been the simple artisan he pretended to be, he would not have dared to take an action that was a direct snub to Cosimo. But he could be sure that Cosimo would take it in good part. It was now vitally important for Cosimo to have the best artists in Florence known to be in his entourage, whether present or not.

To give Donatello credit due him, he was genuinely anxious to keep contact with the less fortunate artists. He took the most practical way of doing it. He kept loose cash in a box hung on a rope in his studio. Any friend in need could help himself. This was a sign not only of his generous nature but also of the fact that he, an artist, had come into real money. He was conscious of his luck. Another Medici, Piero, gave him a farm at Cafaggiuolo, and Donatello was delighted. "Now I shall never die of hunger," he said. But after a year, he gave it back. He could not be bothered with peasants, he said, and if he were to die of hunger, well, so be it.

He could now afford to make such remarks. His price had soared. The equestrian statue of Gattemalata is world-famous. Its merit, unlike that of the *David,* was immediately recognized. One of the antique statues that had never been buried in Rome was that of Marcus Aurelius on his horse. It had been preserved by the Christians because it was thought that the statue represented Constantine, and it still stands on the Capitoline Hill. Comparing the ancient with the new, it was easy to see that Donatello was as good as, and perhaps even better than, any classical sculptor.

Yet not everybody was convinced that genius meant money. The son of Gattemalata, Giannantoni, balked at

the sum Donatello asked. The dispute between them grew hot. Finally on October 1, 1453, eight assessors, all masters of their craft, decided that the statue was worth 1650 golden ducats. We can estimate how far Donatello had come. He had begun his career by working as an assistant to Ghiberti when he was making the celebrated doors to the Baptistry in Florence. Donatello's yearly salary in that post had been seventy-five ducats. The horse and its rider had brought him in twenty-two times as much.

He mellowed with financial success. He even learned to put up with agricultural laborers. He had bought a farm in the Prato. Giorgio Vasari gives a picture of him on his deathbed that throws a bright light on the priorities of the age when wealth was involved. His relatives crowded into the room, and, surrounding his bed, begged the famous artist to leave them his farm. "I can't content you," Donatello replied, "because I want—and I think it reasonable—to give it to the peasant who has worked hard at it and not to you, who have never done anything useful for anybody. Go and God bless you."

His relatives did not ask for his drawings, his unfinished statues, his notebooks. Whatever the merchant princes thought about art and artists, to the common man real money still meant, as it always had done, landed property.

Chapter 4

Money and Michelangelo

With Michelangelo, the artist triumphs. A great deal has been written about him. Some writers have thought him sublime, others terrific but naughty. Percy Bysshe Shelley, for instance, took the trouble to translate his sonnets, but changed the boys to girls. Better-known examples of the same solicitude are the wisps of cloth painted over the male genitalia of his *Last Judgment* by orders of a functionary who forever after has been known as the Breechesmaker. The point was that Michelangelo was such a supremely talented man that his admirers want him without spot or blemish. For some his homosexuality was, in this context, something of a worry.

Michelangelo does not seem to have worried about it at all. He was far too busy worrying about something else—and that, banal as it might appear, was money. According to Michelangelo himself (and he should know) money was the spur of all his astonishing achievements. For those who would skip the following pages, fearing that I am proposing to be iconoclastic, I hasten to add that the origin of Michelangelo's money worries was noble and elevated. All the same, they were a nag.

I must also say firmly that my admiration for his artistic achievements knows no bounds. I have seen the ceiling of the Sistine Chapel: that is, I have really seen it, at 5:00 P.M. fully lit, while I sat on the steps of the papal altar with the chapel quite empty save for a monsignor who instructed me by the hour in the mysteries of the Catholic faith. I have been inside the Vatican during a Roman cloudburst and watched the rain pouring down the dome and the apse of St. Peter's, which left no doubt in my mind that Michelangelo was the greatest architect who ever lived. My admiration and awe have been lifelong. As a boy I pinned up on the wall of my bedroom a photo of his plaque showing Ganymede being carried up to heaven by the eagle, which turned out, years later, not to be by Michelangelo at all. It has even survived a prolonged study of the two frescoes painted by him in his old age on two walls of the Pauline Chapel, the private chapel of the pope. These are quite awfully bad. They are wisely kept away from the public and can only be seen by tactfully slipping into the right

palm a contribution to what the Jesuits refer to as the Vatican Fresh Air Fund—in other words, Michelangelo's prime preoccupation, money.

Michelangelo was born (1475) into the family of the Buonarotti, which was, according to the repeated complaints of his father Ludovico, shabby-genteel. There was never enough money to go around, but there was a family belief that they were descended from an aristocratic clan, the Canossa. Throughout his life Michelangelo rather wistfully sought proof that this was true, looking up his lineage in documents and welcoming an evasive letter from a real Canossa who was currying favor with the now-famous man. Michelangelo never found any real proof, and none has been found since.

From his teens onward Michelangelo could have had no doubt that he was an artistic genius, because everybody constantly told him so. Praise was showered on him so lavishly that a fellow artist-student, Torregiano, lovingly (the adverb is Vasari's) hit him on the nose and broke it for life.

This broken nose shows very well in the portrait bust of Michelangelo in the Conservatorio Museum in Rome. It was made after his death but probably from his death mask. It certainly represents what he looked like to his contemporaries. I have studied it many times over the years because it was, at first, something of a puzzle for me.

Michelangelo had *terribilità*, or so it was said by his awed friends and enemies. This is the Italian word for a prepotency so powerful that it frightens. Mussolini

cultivated the appearance of it when in public. He took pains to look like a dictator because the Italians judge character by a person's face. This is so much an Italian habit, true or mistaken as it may be, that Cesare Lombroso built up a whole science of criminology on it. While this has been discarded, Italian film actors are rigidly typecast according to their faces.

The puzzle of the bust is that Michelangelo did not have the face of a prepotent person at all. It was the typical face of a worried family man, deeply fond of and deeply exasperated by his kith and kin. If we look at his astonishing creations, it is not the right face for him at all; but if we read his letters, it is. He was fond of his family to excess, and his worries about them were the usual ones—the money his family cost him.

He was one of five brothers. He was nursed by a foster mother, his own having died. Neither his father nor any of the brothers ever came to anything much. The eldest, Leonardo, became a Dominican monk, which was promising, except that he managed to get himself unfrocked. The others were drifters, one taking up a temporary job as a mercenary soldier, without, however, making a financial success of it. Another kept a draper's shop, equally unprofitably. All watched Michelangelo with a shrewd and calculating eye.

So did Lorenzo de' Medici, the grandson of Cosimo, and such a thoroughly cultivated gentleman that he came to be called The Magnificent. The young Michelangelo soon caught his attention and Lorenzo enrolled him in the group of artists who studied in a place called The Garden, which was filled with pieces of antique

sculpture (and where, incidentally, Torregiano punched Michelangelo's nose). Michelangelo was given five ducats a month and a rich cloak. Five ducats, it will be recalled, was the price stipulated for Donatello's *David,* so Michelangelo was clearly on his way to making good money. In The Garden he studied under one of Donatello's pupils, Bartoldo. Soon the young man was getting lucrative commissions, and although he was by no means rich, he was earning enough to make his father Ludovico prick up his ears.

On February 14, 1500, when Michelangleo was twenty-five, Ludovico wrote him a typical letter.

> I have five grandsons and I find myself at the age of fifty-six and nobody will give me so much as a glass of water. Besides that I have to cook, sweep, clean the pots and pans. . . . If God takes away my health I'll have to go to the old folks' home. I've got nobody.

It was never as bad as that; with a genius in the family, there was no need for it to be. Michelangelo, in fact, settled his father nicely in life. He introduced him to Lorenzo de' Medici, who gave him a job as a customs officer. This was very generous of Michelangelo since Ludovico had done his best to make Michelangelo's start in life difficult. Lorenzo had asked for the boy to join The Garden. A deputation was sent to the father, who instantly bridled and said that he, a gentleman, had no wish to see his son a "stonemason." It was explained to him that at the court of Lorenzo sculptors were no longer artisans, so, grumbling, he was taken to see Lorenzo. Here he reluctantly admitted that, in front of

The Magnificent, they were all his servants, so Lorenzo could have the boy.

Perhaps Lorenzo best summed up the character of Michelangelo's father when he gave him that job in the customs. Smiling at the man's modest request, he laid his hand on his shoulder and said "You will never be rich."

Ludovico, then, was a far from lovable father—except in the eyes of a genius. Ludovico was clearly an incompetent, a whiner, and a sponge. Michelangelo was none of these things. Everything he did was successful. He was constantly flattered by the great, whereas, as we have seen, Lorenzo de' Medici treated his father with barely concealed contempt, the concealment being due to the fact that he was the father of a dazzlingly gifted son. In a very Italian way it was accepted that without the father there would have been no son. It is not a sentiment that is much in fashion today, but Lorenzo had every reason to feel it. Without the father, the grandfather, and the great-grandfather's amassing a fortune, Lorenzo would not have been at all magnificent.

Michelangelo's feelings went far beyond filial gratitude. His love of his father and his brothers was, to him, at the very heart of his genius. We have his own words to prove it. He replied to the complaining letter I have quoted in no uncertain terms: "I want you to know that all my work has been as much for you as for myself," and in a later letter (August 1508) he makes it even warmer: "You've known me for thirty years, you and your sons, and you know I wish you well."

All this could have been, of course, merely words to

shut the old man up. Not so with Michelangelo. His affection cost him money again and again. Money he earned with sweat and chisel, and which he could very well have spent on himself. He never did spend money on himself. At the height of his fame he continued to live in the squalid studio he had taken on his first visit to Rome, and apart from the court dress that was obligatory, we have no evidence that he spent money on fine clothes or feasting, as was the custom of other successful artists, like, for a spectacular example, Benvenuto Cellini.

By 1516 he had accumulated some spare cash, and he wanted to give it to his brothers. He writes to them that he is prepared to set them up in a shop. He wants no profit on his investment, but "I want to be sure, at the end of ten years, I being still alive, you will give me back the thousand ducats in goods or in money if I want it again. I don't think this will occur."

This proposition thoroughly alarmed a friend of his, who in some remarkably contorted prose argues that he won't get his money back from his brothers and the whole thing will only lead to another family row.

And there had already been a bad one. His brother Giovan Simone had been relentlessly pressing him for money. In a letter written in July 1508, Michelangelo explodes. Here there is certainly a touch of *terribilità*:

> If you had the brains to know the truth you would not say that I have spent so much of my money [i.e., on himself] you wouldn't come here with your own affairs. You would say: "Michelangelo knows what he has written to

me and if he acts like that now, it's because there is some difficulty." Be patient. Don't put the spur to a horse which is going as fast as it can, and faster it cannot. . . .

I thought you were my brother, like the others. Now I'm certain that you are not my brother. If you were, you wouldn't threaten my father. You are a swine* and I'm going to treat you like a swine. I have been going in utter misery up and down all Italy, putting up with every shame, suffering every want, tearing myself to pieces in all sorts of hard work, risking my life in a thousand dangers, solely to help my family. And now, when I'm just about getting somewhere, you want to be one who is going to quarrel and ruin in an hour all that I have done in so many years and with such hard work. By Christ, that's not going to happen. I am ten thousand times better at quarreling than you are, if needs be.

Michelangelo had transferred his headquarters to Rome, where he found a patron and commissions (as I shall presently describe). In 1497 a brother turned up in the city (August eleventh or perhaps the eighteenth) with the demand that Michelangelo settle a debt of ninety gold florins that the father had incurred. Michelangelo paid. Brother Lorenzo next turned up, flat broke and thrown out of his order. Michelangelo dipped into his purse. The grand total of what he paid out cannot be known because not all of the payments were made by correspondence, and of those that were many letters

* Michelangelo writes *bestia,* which literally means "beast." But the word has a much more powerful connotation in Italian when used in abuse.

have been lost. But the tale is clear from those that survive, from which I shall give a few sample facts.

By 1508 Michelangelo had received the contract (on which more in a moment) for the tomb of Pope Julius II in the new St. Peter's. It was an onerous task, and one that, in the event, was never completed. Michelangelo fell into one of those fits of self-doubt that were to plague him to the end of his life. He naturally turned for advice to the father he had been maintaining. He got a dusty answer. Ludovico, in a spelling all his own, wrote him a letter strongly recommending that Michelangelo give up the whole idea of being a sculptor.

That marvelously mistaken piece of paternal counsel sent off, Ludovico set about running up more debts. In 1509 he is sent fifteen ducats, in 1510 six gold florins. In the same year brother Buonarroto falls ill and Michelangelo instantly dispatches 150 ducats. In the same year, without any authorization Ludovico takes 100 ducats from an account Michelangelo had in Florence. (It is tempting to imagine him doing this: "My son—he works for the Pope, you know—will reimburse you.") At first this was too much for Michelangelo. He demanded repayment and Ludovico humbly apologizes but does not pay up. Plaintively, Michelangelo says he will give his father half the debt as a present if only he would pay the other half.

How much money did Michelangelo have to make to maintain the flow? Let us return to 1508. It is a significant year for the history of art, for it was then that Michelangelo received a commission from Julius II to paint the ceiling of the Sistine Chapel. The advance

payment was 500 ducats. Out of this (as we learn from a note from the artist himself) he arranged to bring five *garzone,* young assistants, from Florence, at the wage of twenty ducats each a month. It would seem a legend that he dismissed them and carried on alone. Only one can be traced as leaving. Thus he had four to pay.

In the same year Buonarroto is begging for money, and Michelangelo confesses he cannot help. He himself, he writes, is in debt to the tune of 140 ducats, and besides that, he has 400 ducats' worth of marble for the tomb to pay for. All the same he quickly sends five ducats when a passing visitor tells him that an aged aunt has fallen on hard times.

However, in 1509 he is without money. He is working on two of the most famous works of art of all time—the chapel ceiling and the tomb. Unfortunately (he writes) the pope has not paid him a penny for thirteen months. But things must have subsequently improved. In the same year he sends the improvident father 350 ducats, with the moving last sentence: "Go on living; I would not have you die for all the gold in the world."

The finances of the ceiling of the Sistine Chapel are well worth study. They show a new aspect of a legendary quarrel that has found its way into novels and a spectacular film. Pope Julius II and Michelangelo are usually represented as two headstrong men, both remarkable in their respective ways, whose temperaments clashed repeatedly. Julius is shown as a pope who wished to immortalize himself by having the great Michelangelo paint a vast ceiling, Michelangelo as a dedicated artist

refusing to be hurried even by a pope. The pope goes continually into the Sistine and demands to see what progress has been made. Both men lose their tempers, the pope because Michelangelo will not hurry, Michelangleo (because of his *terribilità*) enraged that Julius speaks to him in that manner. Finally the pope hits the great artist over the head with a stick.

There is no doubt about the truth of the stick. Julius did hit Michelangelo. He was, after all, a warrior. But the rest of the notorious conflict of wills bears closer investigation. In the first place, Julius is most unlikely to have thought that the Sistine ceiling was necessary for his name to be remembered. Popes do indeed make great efforts to perpetuate their names in history, if only because an uncomfortable number of their predecessors are ignored by historians or languish in footnotes. (The most modest of modern popes was John XXIII, yet he has quite the biggest commemorative inscription in all St. Peter's—made at his own orders. Nor can you miss it. It is ingeniously placed so that you cannot get into the basilica without walking over it.)

If Julius had wanted the ceiling to trumpet his fame, he would have insisted on having his portrait included (as was the fashion of the time), or at least a vast inscription, like John XXIII's or that of Paul V on the church's façade. Besides, he had already arranged for Michelangelo to carve him an enormous tomb.

A more practical reason would be the fact that Michelangelo was being remarkably well paid. Julius, as we shall see in the history of the tomb, was never openhanded with money. He contracted with Michelangelo

to do the ceiling for 3000 ducats. But Michelangelo wanted more. The *garzone* cost him 100 ducats a month, to say nothing of the cost of the powders for the painting. And there was, as always, the family clamor for cash.

Julius, finding that hitting Michelangelo over the head did not really result in the work being done faster, gave in. Michelangelo got a second contract, this time for 6000 ducats. He promptly finished the job.

We have evidence that the papal court surrounding Julius by no means regarded the quarrel of the pope with the artist as a struggle of Titans. The master of ceremonies of the period was Paris de Grassis. He kept a meticulous diary of every event that took place in the chapel. Every ceremony is recorded, every name mentioned. Throughout the painting of the ceiling, Michelangelo's name never appears. The frescoes were unveiled with pomp, the pope being present. Again all the names are there—except Michelangelo's. It is plain that the hero of our novels and films and the subject of unlimited scholarly studies was, for the papal court, still an artisan.

The tomb that Julius II wanted for himself and that Michelangelo designed for him would have been the biggest thing in St. Peter's. It also brought Michelangelo the biggest headache about money that he had in his life. Of the great pyramid of allegorical and religious figures that Michelangelo planned he only finished the *Moses* and the *Slaves,* and none of these ever entered St. Peter's. This failure is usually blamed upon the popes who succeeded Julius. The family of Julius blamed it

squarely on Michelangelo, and the artist was sometimes inclined to think that they were right. The history of the tomb emerges from a study of the payments—either made, disputed, or not paid at all.

The contract given to Michelangelo by Julius was for 10,000 ducats. The tomb was to be completed in five years, during which time Michelangelo was not to accept commissions from anybody else. Michelangelo went off to Carrara to choose the marble, where he signed a contract for the delivery of thirty-four cartloads of pieces of marble of various sizes. These were duly carted to the city and dumped outside Michelangelo's studio.

Then the trouble began. Michelangelo wanted the pope to pay him something on account, so that he could in turn pay the carters and the quarrymen, but the papal cash flow suddenly dried up. Michelangelo was greatly perturbed. To make matters worse, Michelangelo heard a rumor from the papal court that Julius had been overheard saying to the master of ceremonies that he "wasn't going to pay a baioco for either the large stones or the small ones." In those days a baioco was a very small coin; the word still survives in the popular dialect of Rome. Michelangelo, on receiving the news that Julius was not going to pay a red cent for all the marble lying outside his front door, went to the papal court to demand his money.

The pope refused to see him. Michelangelo went again to the Vatican on his debt-collecting mission, and once more was refused permission to see Julius. By this time both pope and artist were thoroughly incensed, the pope for being dunned, the artist for being cheated.

Michelangelo stubbornly paid two more visits to the Vatican, and the pope as stubbornly refused to see him. The fifth visit at least produced some action. This time Michelangelo was admitted, only for the pope to order a footman to kick him out. Michelangelo took the hint and, hastily packing his bags, fled to Florence.

Seen in its proper perspective, this is a very common situation. The pope was temporarily short of money and Michelangelo was in the same position. Deeper motives have been sought to explain Julius' action, but given Michelangelo's continuous and pressing need for cash for his family, it is doubtful if they are convincing.

It is true that an artistic difficulty had arisen. The tomb was so enormous that the new church to hold it would have to be enormous too. This was such a problem that Julius at one time toyed with the idea of turning St. Peter's into a sort of mausoleum for himself (and, of course, St. Peter). The design of the basilica was still largely unsettled. Julius had appointed Donato Bramante (1444–1514) to be the architect. Bramante, then in his sixties, was at the height of his fame. He disliked Michelangelo, the much younger man, and it is thought that it was he who caused the quarrel over the money. If we are to accept that view, we must also say that Julius would allow an employee to turn him off the thing on which he had set his heart: the great tomb. The simpler explanation—a row between debtor and creditor—fits the personalities of both men better.

Julius II died in 1513. During the eight years since the signing of the contract for the tomb, Michelangelo

had managed to squeeze some money out of him. Just how much was a matter of stormy debate between Michelangelo and the heirs of the pope.

These were the della Rovere family who, during the papacy of Julius, became very powerful. But the papacy is an elective monarchy. The new pope is chosen by the cardinals sitting in conclave, with the help of the Holy Ghost. Throughout history the Holy Ghost has shown an enterprising liking for variety. Julius had been a soldier and a statesman. The new pope was the great-grandson of that prosperous Florentine merchant, Cosimo, and the son of Lorenzo the Magnificent. Obviously the Holy Ghost had produced a great piece of luck for Michelangelo, if only he could manage things properly. Giovanni de' Medici took the name of Leo X.

Michelangelo was now in clover, but there was a difficulty. He was under contract to the papacy to do the tomb. After the ceiling of the Sistine, he was the wonder of all the wide world, and the Medicis naturally wanted him to work for them. On the other hand, Leo X could not just order Michelangelo to stop work on the tomb of his predecessor. The Medicis had no love for the della Roveres, and their enmity was reciprocated. Yet if Michelangelo went on with the tomb, he would have no time for anything else. Besides, the Medicis wanted some tombs of their own.

The problem was solved. The Medici family church was San Lorenzo, in Florence. They decided they would improve it by giving it a new façade. Michelangelo the sculptor showed a vivid interest in this architectural matter. He went to Florence and postponed work on the

Julian contract. The Medicis further wanted a sepul-
chral chapel. Michelangelo did this too. He gave his old
patrons full measure, pressed down and flowing over.
He decorated the chapel with the two stupendous seated
figures that all the world knows, together with the four
reclining figures that are among his most fascinating
achievements.

The della Roveres were furious—so furious they
frightened Michelangelo. What added to their anger
was that on the death of Julius, Michelangelo had
obligingly signed a new contract with the family. Natu-
rally, as was his custom, the price went up. It was now
16,500 ducats. There was a little haggling. The family
said he had received 3500 ducats during Julius' lifetime,
and since there was no tomb to be seen for it, they
deducted it from the new contract. Michelangelo pro-
tested vigorously, but in the end gave way. That was at
least evidence that he was taking the tomb seriously.

But by December 1523 (ten years later) there was
still no tomb. The della Roveres, having discovered (so
they claimed) that Michelangelo had already received
the greater part of the fee of the first contract, de-
manded that Michelangelo pay interest. Michelangelo
replied that it was *he* who should be paid interest, and
what is more, damages. The grounds on which he made
this claim are not, to say the least, very clear.

Apparently a friend of his, Fattucci, felt the same.
He offered to arbitrate in the quarrel. He dealt with the
Vatican cardinal Sanquattro. They agreed that Michel-
angelo had indeed received, in all, 1500 ducats during
the pontificate of Julius and 7000 ducats afterward: in

all, 8500 ducats, not far short, as the della Roveres had said, of the total promised sum. And there was still no tomb.

In 1525, Michelangelo really got down to work. He sent drawings to the della Roveres, who exploded. The drawings were for a very much smaller tomb. They were forced to yield, inch by inch, but they were exceedingly angry. On November 1, 1526, Michelangelo wrote a letter saying that he was in a great fright because the della Roveres were so incensed, "*è non*," he added, "*senza ragione.*" Not without reason.

Well, we have the *Moses* and Michelangelo had his 8500 ducats. Both posterity and he have come out of it very well. Michelangelo always did.

Chapter 5

Leonardo and Titian: A Contrast

We now come to the rise of a person who is vital to an artist's income, and never more so than today—the critic. That is a poor word for him; it suggests hostility. But the critic I am now speaking of is the reverse of hostile. He praises the artist to an indifferent public, often in extravagant terms in an attempt to alter its attitude. We have a Victorian example of this in John Ruskin's eulogy of Jacopo della Quercia. The first man to act as a high-class publicity agent for artists was Leon Battista Alberti (1404–1472).*

* Alberti also wrote on architecture, religion, domestic animals, law, politics, mathematics, language, and literature. He wrote poetry and fables, and developed the art of surveying and the camera obscura.

In 1436 he published an essay (*Della Pittura*) that had considerable influence in the struggle of artists to rise above the social level of artisan. Alberti was an architect of great gifts. In his book he points out that an artist is essentially a very exceptional man. Since he paints human beings, he must have a thorough knowledge of human nature in all its aspects. Since he paints them in action, he must understand how they actually do go about their affairs. He is interpreting Nature: he must therefore understand Nature's laws and thus must be a scientist. He must even be a mathematician, because perspective (much discussed in those days) is a mathematical study. With all these abilities the artist, says Alberti, is clearly a cut above most other people.

Obviously there is some exaggeration in this, agreeable as it was for an artist to hear. Painters did not discover the rules of perspective by doing sums or reading Euclid. They did it by observing a scene from a fixed viewpoint through a pane of glass and marking the salient features on the glass itself. If these points are joined by lines, perspective at once becomes clear. Had Michelangelo bothered his head about the laws of Nature, he would have seen that several of his figures on the Sistine ceiling were in great danger of falling down onto the floor of the chapel. Renaissance artists used their eyes rather than their brains. They looked about them and recorded what they saw. Bronzino's young men are still to be found in Florence—Bernard Berenson's "tactile values" walking about in jeans—and Madonnas can be seen all over Italy, on their knees in churches or dandling their offspring.

Alberti's aim was to equate the artist to a Renaissance ideal—the man who took all knowledge as his province and at the same time had immense practical abilities. He wished to raise the status of the artist by giving him attributes not shared by the common run. We do the same today. Paul Klee, in his Bauhaus lectures, would urge his pupils with all his force to see what he calls the inwardness of things, even of a squiggle, and so emphatic was he that an artist was no artist unless he had this unique vision that, as he confessed to his wife, he would leave the podium feeling like a limp rag.

There was one man who measured up to Alberti's ideal and even surpassed it. He was Leonardo da Vinci.

Leonardo is a modern hero. Not only did he invent two objects that might well be used as symbols of our own time—the tank and the flying machine—he also painted the world's two most popular pictures, *The Last Supper* and the *Mona Lisa.* His morals were permissive: he was a pederast and made no bones about it. As we see him today, he appears to be one of the most fortunate men who ever lived. Immensely talented both in the arts and engineering, a seminal painter, a superb draftsman, gifted with an endless curiosity about the world around him, handsome even in old age, flattered and sought out by the great, honored beyond measure by a French king in whose arms he died.

It was not quite like that.

Leonardo "from Vinci" (as his famous name means) was born (1452) into a respectable family in a small provincial town near Florence. Unlike Michelangelo, he

had no trouble from his family throughout his life. We know next to nothing about his childhood, and Sigmund Freud's attempt to fill the gap was not the happiest of his psychoanalytic excursions. Leonardo had a recurring dream as a child of a bird that repeatedly hit him on the lips with its tail. Freud, believing this to be a vulture, delved deep into the historic symbolism of this dire bird and drew many conclusions about Leonardo's mind. Unfortunately the bird was a kite, a mundane animal. Freud was working from a German translation and the translator had erred. Anybody who has labored over the Florentine prose and vocabulary of the period will easily forgive him. For the purposes of this inquiry I shall take it for granted that Leonardo had one of the most remarkable minds that ever existed, and I shall leave it at that. I wish only to show that his astonishing brain did not bring him the rewards he had a right to expect. His life, usually considered to be a continuous triumph, was in fact a series of setbacks, and he lived in considerable (though not dramatic) poverty. He often lacked money, and never made much.

It is customary with Renaissance artists to emphasize the masters under whom they learned their art. It is thought that Leonardo studied under Verrocchio—they share a certain elegance of line—but this is not fully established. We know that Leonardo was accused when he was a young man, with two other persons, of frequenting the house of a notorious boy prostitute. On this occasion he gave his address as Verrocchio's house.

Inevitably he joined Lorenzo de' Medici's collection of talented youths, but Lorenzo does not seem to have

taken particular notice of him. His multifarious talents were obvious, and perhaps Lorenzo—who, as we have seen, was a shrewd judge of character—foresaw that this would be a stumbling block in Leonardo's career. At any rate, whatever hopes Leonardo had about his patron were cut short.

At this time another family had risen to power in Milan. The Sforzas were also patrons of the arts. Ludovico (called Il Moro) was the ruling duke of the city, and Lorenzo packed the young genius off to him. He recommended that Ludovico hear him play on a lyre he had made. Curiosities were very popular at Renaissance courts, and this lyre was curious indeed. It was made of silver, sculpted by Leonardo, and had the shape of a horse's head. Ludovico Il Moro became his patron, but it would be a mistake to think that he showered gold ducats upon him like some Renaissance Maecenas. Leonardo, who was thirty, had to fight for a living, like any other artist of his time.

He had written an extraordinary letter to Ludovico, introducing himself. In this he offered, first and foremost, to be a military engineer. He would, he wrote, design original engines of war and siegeworks that would infallibly defeat the enemy, and he added a list of other similar activities in which he claimed to be adept. Only at the very end, and then almost reluctantly, does he bring in the fact that he is an artist. He would also, he says, do "a horse" for Ludovico. The "horse" was much talked about at the time. Ludovico wanted an equestrian monument to his father Francesco.

He did not commission the horse. Instead, he set Leonardo at the job of entertaining his court. Life in a princely court has long hours of utter emptiness. These had to be filled in somehow. In some courts they sat around and told stories or made up songs. In others they played party games or got up shows in which the courtiers took part.

Leonardo threw himself into this work and soon won a glowing reputation. He acted as a musician; he organized parades and pageants; he thought up games. He was particularly popular for his rebuses, his conundrums, and his fables.

It is this phase of Leonardo's difficult life that has been reported to us. He had a beautiful face in a country which has always admired physical beauty. He had, we are told, silken hair, of which he was very proud. His conversation was varied and fascinating. He was an accomplished courtier, and in court, as we have noted, the prince sees to it that his dependents are very well dressed. He was popular with women—you cannot invent party games without winning their approval— and because of his pederasty he had that aura of unapproachability so attractive to women. As a hero of our times, this gilded life is just what we would have for him. We put aside the dismal thought that he was just an aide-de-camp wasting an immense talent on trivialities.

But I wish now to take that thought up and to examine what sort of life the serious Leonardo actually lived. Fortunately, we have the required documentation.

Apart from the frivolities of court life, Leonardo

was a painter, in Milan. Florence under the Medicis was just beginning to realize the merits of artists. It was not so in Milan. The life of a painter there was grim indeed. To get paid at all one had to grovel. Constantino da Vapiro had worked for the Sforza family. He had been asked to design some decorations for Galeazzo Maria Sforza on the occasion of a marriage. In desperation he writes that he is in extreme need of money. If only the Sforzas would pay for the work already done, he offers to forego the usual advance for the decorations. Zanetto Bugatto, another artist, was very popular at the Sforza court. Popular, but not paid his due. He writes to the duke that he is being sorely pressed by his creditors. He begs the duke to help him in his distress and to *pay up* for the portraits he had already painted of the duke, his wife, and his firstborn. He also asks him to pay for "the dog called Bareta, for which, so far, I have been paid nothing."

In this world of clamoring creditors, bilking dukes, and unpaid-for dogs, it was only natural that artists should band together to share what crumbs there were from the rich man's table. It is difficult for us in these days of the absolute autonomy of the artist (how could an artist be anything but autonomous?) to hear of artists combining and working on a commission as a team. Yet one of Leonardo's most famous pictures, the *Madonna of the Rocks,* was painted under such circumstances.

In this hostile city, Leonardo had wisely joined forces with two other artists, the brothers Ambrogio and Evangelista Preda. Ambrogio had good connections. Soon he came up with a contract from the Confraternity

of the Conception (April 25, 1483). The confraternity had an unfinished altarpiece made by one del Mauro. The three associates agreed to gild the frame and supply it with pictures. The middle picture had to show "Our Lady with her son, done in oils, with every perfection, with two prophets painted smoothly and in delicate colors." The work had to be finished by the Feast of the Conception (December 8) and the price was fixed at 800 imperial lire, 100 to be paid in advance and forty each month.

The work was done, but the confraternity was no better than the duke at paying up. The trio (among them, let it be remembered, the universal genius Leonardo, who had done most of the central painting) lost their tempers. There is a supplication to the Duke of Milan (Ludovico Il Moro) begging him to intervene. (The document unfortunately bears no date, but by its very nature we may assume a good time had elapsed.) They asked the duke to make the confraternity pay. They add that the market price of the picture had gone up in the meantime, as well it might, since the price of the *Madonna of the Rocks* has been going up ever since and today it could not be bought for ten million dollars. The three are more modest. They wanted 300 ducats, equivalent to 1500 of the imperial lire quoted in the original contract. If the confraternity did not want to pay that much, the three had found a buyer who would.

The brothers of the confraternity offered a miserable twenty-five ducats. The trio demanded a hundred. It was agreed to submit the dispute to the arbitration of three brothers of the confraternity, a fair enough offer.

What these three decided the picture was worth we do not know, but they had guilty consciences, because we learn from the supplication that they refused to confirm their opinion by swearing on the Holy Sacrament.

The wrangle went on until 1506. Then a compromise was reached. Two delegates from the confraternity were to meet with an expert, Paolo di San Nazaro, and fix the final price. In resonant Latin, the committee reports that the picture was not finished. Leonardo is adjured to finish it in two years and the confraternity ordered to pay 100 lire for each of those years. Thus the laborious hire-purchase deal was completed to everybody's satisfaction—after twenty-three years' delay.

No doubt it gave the brothers of the Confraternity of the Conception pleasure to have a splendid picture by the celebrated Leonardo from Vinci on their altar for twenty-three years without having paid for it. And there was always the income on offerings from people who just came to look at it.

But Leonardo was an exceptional man. Unlike most artists of his time, he had the last laugh. Anyone curious to come near to this genius (and who is not?) should visit both the Louvre in Paris and the National Gallery in London. There he or she will see the *Madonna of the Rocks*—twice. Both are obviously painted by a master hand. They are the same except for some small details. The brothers of the Conception did not get their two prophets. They got only one, and that a baby. Both pictures show the infant John the Baptist adoring the

infant Christ. In one version the baby Jesus points a finger at St. John as though saying "Look!" In the other he does not. The rocky cave behind and the Madonna show no significant differences, but such as there are go to prove that one picture is not the work of a mere copyist.

Which is the "real" Leonardo? The question has been a battleground for experts for decades. On the whole, patriotism wins the day over judgment. The French feel that theirs must be the real one, the British plump for theirs. But neither side is prepared to say that the other is totally deceived.

Now it is known that Leonardo painted just such a picture before he went to Milan. It has been ingeniously suggested that this one must be that in which the Christ child points a finger at St. John, because the Baptist is the patron saint of Florence. Furthermore, the pictures differ in size. It is possible that when Leonardo signed that peremptory contract along with the brothers Preda, he told them privately that he had a picture that would "do," and all that was needed was for him to make a copy of it that would fit. Painting a picture again on the lines already worked out was far less work than thinking up something new. Although experts will come up again and again with a definite solution of the problem, we have only to wait a year or two for another expert to prove that the solution is wrong. My own feeling, which has nothing to do with art criticism, is that all parties felt aggrieved, but it was finally settled with a typical Italian compromise all around.

We have seen the elegant impression that Leonardo made on observers in his lush life while at court. Was he the same at home?

He early on developed the habit of keeping note-books. These, of course, are the famous ones on which his reputation as an all-round Renaissance man rests. As he grew older he became so enamored of note-taking that he attached small manuscript books to his girdle. His notes, which refer to practically everything he saw, are rarely personal. But when they are, they give us a picture of a man far from the well-heeled courtier. One note complained of his lack of clothes with a list of things that he is badly in need of. When the brothers of the Conception finally paid up he goes on a buying spree. Once more there is a long list of clothes, but this time safely in his wardrobe. He must have looked, for once, quite a dandy.

That was when he was in luck. Another time he is continually making notes about his spectacles. Glasses were expensive in Milan, and it is clear that he was worried about losing or breaking his. On another occasion we get a glimpse of his frugal style of living. He has gone shopping for his dinner. Like anyone short of money, he keeps careful accounts of where the cash went. Six lire was for wine and two for bread. He bought one egg and four eels and also some broccoli. It was scarcely a banquet that one of the three most famous artists of the age sat down to. The fact of his poverty must sometimes have oppressed him. One note says *"Per farsi dire la ventura soldi 6."* He had gone to have his fortune told.

He was in debt. In 1491 he owed money to the cathedral chapter at Milan, but the best evidence of the straitness of his means is the tale of little Giacomo.

About the time Leonardo (now nearing middle age) was unable to pay his small debt to the cathedral, he took a fancy to a small boy of ten. There is no call to associate this with his open homosexuality. Giacomo, the boy in question, was a specifically Italian kind of child. He was, as the Italians say, a *monello di strada,* or, in Naples, a *scugnizzo.* The words, baldly translated, mean "street urchin," but in fact much more. These boys have a combination of charm, liveliness, affection, and broad humor that is not to be found elsewhere. Something of the Jewish chutzpah is there, but less ambition. They are quite used to middle-aged men falling for their charms.

Leonardo liked to dress Giacomo up. T. H. White, the author of *The Once and Future King,* which later became the musical *Camelot,* spent the money he made on just such a hobby. I have been shown, in Naples, the photographs of the dressing-up by the boy concerned with much nostalgia. White used to take his *scugnizzo* to expensive seats at the opera in order to improve his education. It is fair to think that Leonardo had much the same plans for Giacomo.

Unfortunately, seizing his notebook, Leonardo records for all posterity that little Giacomo is "a thief, a liar, obstinate and greedy"—a perfect description of one side of the character of a *monello di strada.* In reply, Giacomo, so the infuriated Leonardo notes, spilled wine three times when serving at table.

Worse was to come. We have noticed Leonardo's

worry about clothes. Somebody had given him some leather with which to make boots (like spectacles, good soft boots were an expensive commodity). Giacomo had already gone into the art business. He had stolen a print given to Leonardo and sold it. He now stole the leather and (we owe the information to the same notebooks over which scholars have pored for generations) sold it to buy "anici and confetti"—aniseed balls and sugared almonds. It was no doubt reprehensible of the little rascal, but he cannot be blamed too severely. Here he was, the apple of the eye of an artist much lauded by the duke himself and all the gentry, who had, incomprehensibly, not enough cash to buy himself candy. It was logical for the ten-year-old to conclude that Leonardo was simply being stingy.

He was not. He lacked money, and nothing makes this clearer than a detail in the background, rarely mentioned, of one of the most celebrated events (or rather, nonevents) in the history of art.

Leonardo was commissioned to decorate one wall of the Great Hall of the Signoria of Florence, Michelangelo the other. Leonardo chose for his subject a moment in a battle, that of Anghiari. He got as far as drawing the outlines on the wall, but then procrastinated. This has so fascinated art historians that for two years in the nineteen-seventies, the Great Hall was cluttered with scaffolding on which at vast expense was mounted a piece of involved scientific apparatus that, it was claimed, could see through the fresco painted over Leonardo's design. The apparatus was, it turned out, of the same family of

marvels as that which was to show us little green men on Mars. It could see nothing.

Piero Soderini, who was in charge of the work in progress, was in much the same position. He could, of course, see the outlines, but that was all. On October 9, 1506, he took action. He complained to the authorities that Leonardo had already taken a lot of money but had done very little work. He complained to Leonardo, too, when he was handing him an installment of the cash. Leonardo was mortally offended. He exclaimed that he was not an artist who worked for money, or rather, to get the full value of the word he used—*quattrini*—he could also have meant "small change." He refused to take the money. He went around to his friends and together they came up with enough to pay Soderini back the sums he had already disbursed. Soderini has his niche in history. He refused the repayment, knowing that Leonardo could not afford such gestures.

We can find a reason for this lack of money in the history of "The Horse," the name in court and artistic circles for a monument that Ludovico Il Moro wanted to erect to his father and that, as noted, Leonardo was willing to do. Sometime between 1483 and 1489 Ludovico got down to business about it. It would not appear that Leonardo was an inevitable choice. Ludovico first asked for recommendations from other artists and masters. Finally he chose Leonardo. Leonardo agreed, but asked that the salaries of one or two assistants (*maestri*, not *garzoni*—competent and mature men, not apprentices) be included in the deal.

Ludovico agreed. Leonardo, in his typical way, plunged into a study of horses.

We have his notes on various striking horses he sees in his researches, and the names of their owners. Above all, we have a stupendous page (in the Windsor Collection) of studies of a horse rolling on the ground. Not until the invention of photography would a moving horse be seen with such a swift and accurate eye. The horse that Ludovico wanted was not, of course, to be seen rolling on its back, but the bonds of art and a contract could not restrain Leonardo's curiosity.

In 1490 Ludovico made inquiries as to the work in progress, or rather the work that had made no progress at all. Leonardo replied that he was quite ready to do any work for the duke, "but of the Horse I'll say nothing, since I know how things are." This cryptic remark is immediately explained. Leonardo states that for two years he has not been paid any salary at all, although he has had to shoulder the expense of keeping the two assistants.

However, the same year he did begin work. In one of his notebooks we have this entry: "23rd April 1490 began this book, and began again on the horse." Francesco, the subject of the monument, was forgotten by Ludovico, Leonardo, and the public. The Horse was the thing.

It turned out to be a tremendous horse. Leonardo made a huge clay model, and all the world came to admire it. It was considered the finest horse that had

ever been sculpted. Some skeptics doubted if it could ever be cast. (The problem in all casting is that the metal must flow evenly as it is poured into the mold.) Leonardo was sure that he could find a solution, but it turned out that he could not. Years later the horse was still in its clay state. In 1499 the citizens of Milan, tiring of Ludovico's misrule, offered the city to the French. On October 6 Louis XII entered the city in triumph, with his army. There could not be a better or more loyal target for his soldiers than the horse that some artist or other had made for a monument to the enemy, the Sforzas. They shot the clay model to pieces with the bolts from their crossbows.

Leonardo's failure was more talked about than his abilities as an all-round Renaissance man. In 1513 he went to Rome in search of work. The papal court gave him some, but at the meager salary of thirty-three ducats a month, and it is not surprising that he did nothing. The leading artists of Rome were then, in any case, Michelangelo and Raphael. (Raphael, everybody's darling, when painting frescoes charged so much a head, according to size, a very sensible solution to the money problem.) On one occasion Leonardo was with a group of learned Romans. They were discussing a passage in Dante, and they wanted Leonardo's comment. At that moment, Michelangelo walked by. Each disliked the other. Leonardo, with an ironic edge to his voice, said, "Here comes Michelangelo. Ask *him*." The sarcasm must have sounded all the more telling because of Leonardo's Florentine accent. It is a fine language in which to be

cutting. Michelangelo flew into a temper. "You ask *him*," he said to the group. "That one there who designed a horse to be cast in bronze and couldn't cast it—and for shame left Florence."

It was very rude of both great men. Perhaps, as so often happens in Italy, they had not read right through Dante, and the passage escaped them.

Both were, on the other hand, famous for not finishing work they had undertaken. Whether this was the fault of these two geniuses, or whether it was due to the clumsy and inefficient way of paying them, is a matter to be weighed by their admirers on the evidence that this inquiry has produced. Our fathers and grandfathers, living in a financially secure world, were inclined to attribute it to something they called "the artistic temperament." I shall trace the origins of this notion in the next chapter.

Rome was no place for Leonardo, and neither Florence nor Milan had brought him the solid success that was his due. Fortunately for him, there were the French. The power of France was increasing steadily, but in the arts it lagged well behind Italy. It is still the custom in Rome, when showing a cultured Frenchman around the city, to warn him that every masterpiece of architecture he sees is a hundred years earlier than he thinks.

Francis I determined to remedy this. He invited Leonardo to come to France and be the "First Painter, Architect and Engineer" of his court. Leonardo accepted. On his journey to Paris he was accorded every possible honor. Emissaries from Francis met him at

every stop. On arrival he was given the small castle at Cloux as his own, and a salary.

By this time, a paralysis of the arm made it impossible for him to paint, but his days were tranquil. He did not die in the king's arms. For a practiced courtier like Leonardo and a man like Francis, who was every inch a king, such a scene would have been embarrassing to both parties. Instead he was cared for by the young man, Francesco Melzi, who had been his companion for years. Francesco's heart-broken letter to Leonardo's brother announcing his death is evidence that those who had judged Leonardo to be the most fascinating and charming of men were right. Francesco says that Leonardo had been a father to him, and that now he was gone, life could never be the same.

Leonardo left Francesco all his papers in his will. These included the now-famous notebooks. Francesco thought them curiosities and, perhaps, with their strange calligraphy, not entirely good for his master's posthumous fame. He did not sell them, and they have come down to us by a series of chances. Francesco himself lived out his life in comfort, and those who met him described him as "a very gentle gentleman." In that phrase we can see, as in a looking glass dimmed by the years, something of what Leonardo must have been like to know.

The artist had been raised from the status of an artisan by merchants. The merchants had, as the generations passed, become merchant princes, then princes in every sense of the word. To take the final step through the barrier to fame and financial fortune, artists needed

more merchants, preferably those who had no ambitions for the trappings of hereditary state. They were to be found in Venice.

In the Dark Ages the Venetians had built their city on a series of islands to avoid the barbarians who were pouring over the Alps into Italy. With the shrewdness that was to remain their characteristic, they had observed that the barbarians were invincible on land but very clumsy in boats. At first the Venetians were little more than fishermen. In accordance with the time, they elected a leader or *dux,* a word which in their dialect became *doge.* With the Adriatic at their doorstep (and today, over it) they became excellent sailors. This led to their development as a great trading community. For this the city was admirably situated. It was the entrepôt between the riches of the East and Western Europe, starved for the silks, spices, jewels, ivory, and a dozen other products of China and India. As merchants they did not rely solely on their shipping; they also went as traders on foot. Marco Polo was a Venetian.

The merchants of Venice stayed merchants and did not become princes (the word *merchant* in Shakespeare's play about Shylock would immediately call up a picture of Venice in the minds of his audience). This they did by an ingenious system of government that has been much misunderstood; it is essential to know its outlines because it had a deep effect on the lives of the artists who lived under it.

It was, of all contradictions, a firmly bourgeois aristocracy. Venice was ruled by a group of merchant families whose names were inscribed in a register called

the Golden Book. Although the wealth and influence of Venice expanded enormously in the course of the centuries, the number of these families never exceeded sixteen hundred. The privilege of being in the Golden Book was hereditary, the only way of breaking in being to make a great deal of money in trade. Shylock's agonized cry "My ducats, my ducats" was not specifically Jewish in Venice. It was the thought uppermost in the mind of all the citizens.

This merchant elite dealt with the doge with considerable political cunning. On the one hand they slowly took away his powers; on the other, as they did so, they greatly increased the reverence in which he was held. Thus arose, in the view of other European monarchies, the opinion that Venice was ruled by an all-powerful autocrat who wore a peculiar hat. The reverse (except for the hat) was true.

The main legislative body was the Great Council. This was too large to be effective, so senators were chosen (Shakespeare's *Othello* opens with a reminder that everybody would listen respectfully to a senator). From these were chosen a Council of Ten who were the real rulers of the city.

All of these bodies had their own special hall in the Doge's Palace, and in addition there was the hall of the Golden Book, and the doge's own apartment. All of these needed decorating. Since the paymasters of the decor were rich merchants, they had to be painted in the most opulent manner. In one of them still exists the biggest oil painting in the world (by Tintoretto).

The merchants of Venice were also good Christians,

or at least as good Christians as diligently serving both Mammon and God allowed them to be. They therefore built churches, and these too needed paintings. A school of artists arose to serve both purposes, that of decorating the great halls and the churches. It became one of the most impressive schools of painting in the whole history of Western art, and no national gallery today is worthy of the name unless it contains examples of the work of such men as Bellini, Titian, Veronese, Tintoretto, and the epigoni of the decline, such as Canaletto.

From the first, the financial arrangements between the artists and the governors were those of businessmen, pure and simple. No great family wished to boast of the artists it had taken under its wing, as was the habit of the Medicis and the Sforzas. The Venetians wanted their city to look splendid, much as a bank uses marble in its headquarters, and for the same reason. They wanted to impress all comers that they had plenty of money, and Venice swarmed with foreign businessmen, not only from Europe but also from the Orient.

The painters were, at first, content to call themselves "Madonna-makers." But Giovanni Bellini developed his powers to such degree that the wise merchants saw that he was as much an asset as the gigantic bell tower they had raised beside the cathedral. Venice, for Italian artists, became the place to go because the money was there, and available without kowtowing to princes. Giovanni Bellini learned from Antonello da Messina the new technique of painting in oils that had been invented in northern Europe. His painting of the doge Leonardo Loredan, one of the best-loved portraits in history,

displays not only Bellini's skill but also that the doge in question is a cypher and knows it.

Venice was run on the profit motive. The merchants took considerable risks—ships might sink, or be captured by Moslem pirates or be taken by the enemy in time of war. Again Shakespeare is an excellent guide: the plot of *The Merchant of Venice* is set rolling by the loss of a ship. The merchants therefore regarded profit as a just reward for their abilities. Thus they saw no reason why an artist, in a profession quite as risky as theirs, should not make a profit too. So for the first time since the days of Greece and Rome, we find artists, provided they worked for the Venetians, growing rich. As an example, I shall select one of them, Tiziano Vercellio, known in English as Titian.

Titian was born in Cadore, a small town with a view of the Alps. As a little boy he went to the place where the money was and joined the studio of Gentile Bellini, the brother of Giovanni. He soon learned everything that Gentile could teach him, and so passed to the studio of Giovanni Bellini, where his abilities rivaled those of his famous teacher. His reputation spread rapidly, and in 1513 we find that Pope Paul III had invited him to Rome. Always a wise, not to say shrewd, manager of his career, he did not accept. Instead he wrote a letter to the Council of Ten. In it he offers to paint the Hall of the Great Council, "not so much for money as to gain fame"—a rhetorical flourish he would later regret. He then goes on blandly to state his financial terms. He wants 100 ducats a year (modest enough) and also the customs charges levied on the headquarters of the

German merchants present in Venice. In addition, the Ten must pay for the usual two assistants and the materials. The Council replied with great promptness, and I have read in hagiographers how this showed Titian's early fame. The truth is different. The Council of Ten were businessmen and not princes. In a note in the record written by Marino Sanuto (May 29, 1513), the Council took Titian at his word. He *was* to do it for fame, because they would pay him no salary. He would have funds for the two assistants and the purchase of colors. Titian had overreached himself, and, as we shall see, was to do it again.

He began the picture, but commissions poured in upon him, and he abandoned it. In 1537, the Council of Ten insisted on its pound of flesh. They made Titian, now truly famous all over Europe, finish the picture. But Titian had also made his point. As a painter accredited to the Council of Ten, he could demand high fees from private patrons, and, as the galleries of the world attest, they flocked. But princes were still princes.

They could command talent, and, if they could not pay as much as the merchants, they could still dodge settling the bill. In 1529 Pope Clement VII crowned Charles V as Emperor of the Holy Roman Empire. This grand ceremony took place at Bologna, and Titian was there. He painted the official portrait for which the brand-new Holy Roman Emperor graciously gave him a ducat. To save everybody's face, Federico Gonzaga added 150 more.

Charles V in due course learned about the new status of artists and what payments they could now

command. Still wary of paying cash, in 1533 he invited Titian to Spain. With the invitation, the emperor sent the insignia of a knight of the Golden Spur, which included a golden chain. Titian was proud of this chain and wears it in a self-portrait. The emperor also made him a count palatine, a noble, that is, of the imperial palace in Spain. Titian said he would go, sent some pictures (which were lost at sea) and never, in his whole life, went to Spain.

In 1541 Charles' education in art went further. He gave Titian a pension for life of 100 scudi a year. In 1548 he doubled it. By this time Titian was living in luxury in a Venetian palace of his own. Francesco Priscianese was invited to one of the banquets Titian, a sociable man, was in the habit of giving. The other guests were Sansovino, the architect; Nardi, the historian; and Pietro Aretino, who by means of a vast outpouring of letters was the first journalist of the arts in history. Priscianese describes how they walked among Titian's pictures, strolled in the garden, and finally sat down to a supper "of the most delicate food and most precious wines." The merchants of Venice had brought artists a far cry from Leonardo's egg and four eels.

There is a story that Charles V one day visited Titian's studio, surrounded by his courtiers. Titian dropped a brush and the Holy Roman Emperor stooped and picked it up for him. In my youth the incident was very popular among schoolteachers, and I can remember a painting showing it, with the courtiers holding up their hands in horror. It is an unlikely tale. Charles knew quite well how Titian painted, since he had posed for the

artist. On one visit to the imperial court (then outside Spain) Titian had dashed off no fewer than seventy portraits of various inmates, which could have left little curiosity as to his methods of work.

But Charles was given to dramatic gestures. In 1556 he resigned his crown to his son Philip II in the Netherlands and to his brother Ferdinand in Spain. He spent the rest of his life in a monastery. So it is just on the verge of possibility that he made some sort of tribute to the artist along the lines that the tale suggests. It would have been worth it. *He never paid Titian a cent* of his salary, either the first one or the doubled one. Titian dunned him without mercy, but got no money.

Philip II, shocked by his father's death, paid the arrears in full, thus adding considerably to Titian's growing riches. The emotional upset over the death of a father does not usually persist very long in a son. Philip renewed Titian's contract as court painter, but in paying, he followed his father's footsteps. Nor was he so greatly impressed with the much-praised genius from Venice. In 1550 Titian went to Augsburg and painted his famous full-length picture of Philip in armor. The king sent it to his aunt, Mary of Hungary, with a letter (May 16, 1551).

"It is easy to see," writes the monarch querulously, "the speed with which it has been made, and had there been more time I would have had him do it over again."

He would have found the interview difficult. From his Venetian merchants Titian had learned much in the art of bargaining. He could, like all good hagglers, plead poverty with a straight face when he was rolling in

money. Philip did not pay, and toward the end of his life
Titian wrote him:

> I do not know how to find a way to live in this my old age
> which I devote entirely to the service of your Catholic
> Majesty without serving others, not having had ever a
> cent in payment for the work which from time to time I
> have sent you.
>
> <div align="right">Your servant of the age of ninety-five.</div>

The letter is very interesting. In the first place he
never was devoted "entirely to the service" of his maj-
esty. He was busy all his life turning out pictures for
dozens of other patrons. In the second place, in his old
age he was living very comfortably on the proceeds of
his immense industry. In the third place, he was not
ninety-five. The church records at Cadore of his baptism
have been lost, but a comparison of dates shows that he
had added at least ten years to his actual age. The
portrait, however, of a near-centenarian painting dog-
gedly with his palsied hand while nibbling a crust and
brushing the crumbs off of his tattered tunic is one of
the best Titian ever designed.

He died rich and honored. He showed his grasp of
business to the last. He wanted to be buried in the
Franciscan church of the Frari. The delighted brothers
looked forward to a handsome sum of money to pay for
the tomb. Titian bargained them down until he got his
grave in return for a painting. Artists, at last, had
learned the worth of their work.

Chapter 6

The Artist as a
Financial Success

I am sure that by now I have some readers who, however privately, are growing impatient with the famous men with whom I have been dealing. To them it must seem irritating that artists who could spread paint acceptably over large areas could not bring themselves to realize a fundamental fact of life—that two ducats and two ducats make four ducats. Men who could walk with popes and dukes should surely have been able to get their due reward without so much muddle and confusion; or, if they were weak at arithmetic and the profession of accountant had not yet been invented, at least they could have employed some retired Lombard banker (there

must have been hundreds) who, in exchange for a portrait of himself, would have kept their affairs in order.

To such sensible readers it must seem a long time to wait until we get to Picasso, who, as we saw at the beginning, knew how many beans make five. As a matter of historical fact, one of the most famous painters who ever lived shared those sentiments. Peter Paul Rubens knew how to make money, and he made a great deal of it. The more money he made, the more his fellow artists admired him, which did not always happen to Picasso. Rubens was clearly a remarkable man.

Peter Paul Rubens (1577–1640) was a Fleming who lived most of his life in Amsterdam, where his over-whelmingly luxurious house is one of that city's principal tourist attractions even today. The people of Amsterdam have always been known as shrewd businessmen, but I do not think it quite fair to attribute Rubens' financial success merely to a geographic accident of birth. Henry Ford was born in America, a big country badly in need of motorcars. But Henry Ford had a special gift: he invented the production line for automobiles. Rubens did exactly the same three centuries before him, but for pictures.

There was a time, in my youth, when one could not walk out into the street without seeing one, or many, of Henry Ford's products. It is difficult to go into any good European gallery and to dodge those of Rubens. It would seem incredible that one man could paint so many pictures—and, of course, he did not.

Rubens was the son neither of a painter nor of a

merchant. His father was a diplomat. He was not a very good diplomat. Tallyrand (who was) once showed a visitor his young staff busily at work at their desks and remarked, "None of them, thank God, is an enthusiast." Rubens' father was sufficiently enthusiastic to go to bed with his employer, Princess Anna of Saxony, who had a baby by him. This landed Jan Rubens in prison—a very comfortable one, since he was put under house arrest. There, in 1577, Peter Paul was born.

When he was yet a lad, it became clear that he had a formidable talent as a painter. He could do anything with a brush.

That cannot be said of even the greatest of his predecessors. Michelangelo, after mighty struggles of the spirit, always turned out the sublime. Titian was a master of color and his pictures are invariably ablaze with it; nobody could touch him at flesh tints, and he works them in everywhere. Raphael could paint meltingly lovely faces, and he was always happy to oblige (as noted, at so much a head). Rubens, although he was humble before every great master, came to the breathtaking conclusion that he was capable of doing everything they could do; not better perhaps, but as well— and moreover all on the same canvas, which would save time and money.

He therefore undertook what would today be called a market survey. He went to Italy and assiduously studied and copied everything past patrons had been prepared to pay money for, however reluctantly. He then returned to the North and set up a studio of his own.

The Artist as a Financial Success

It is possible for a lover of art not to like Rubens very much, particularly if he has little taste for overweight females in the nude. I remember years ago, before galleries were air-conditioned, having the impression on a hot summer afternoon that the poor women must be sweating.

But those, like me, who did not always like Rubens are wrong. Painters know better. From the day of his death in 1640, almost every artist who has won fame down to modern times has studied the master, copied him industriously, and learned. He is an encyclopedia of what the artist has to do and, more important, what has been done before him. Rubens, it would appear, in his old age grew tired of being so good and almost casually invented landscape painting as we know it. One has only to stand in front of his painting called *The Château de Steen,* in the National Gallery in London, to realize how very great he was. Without him we should not have had Claude or Constable, or Cézanne or many others. Those cool, receding planes marching securely to the horizon are the work of a supreme genius. And there is not a fat lady in sight.

Rubens set up business in the way with which we have grown familiar. He became court painter to the Duke of Mantua. The duke also was true to form. He did not pay Peter Paul his salary, but Rubens did not react to this in the usual manner. He did not hang about, begging. He left. He returned to his native land and never looked back—financially, that is. He always had the greatest respect for what he had learned from the Italians. He merely showed them how to turn a talent

into steady money. In later life he too had patrons, the
royal house of Hapsburg. He complained about them,
but in distinctly new terms. He was, he wrote (Septem-
ber 23, 1609), "bound to them by golden fetters." In
other words, they paid.

All the same, he had his financial difficulties. He also
had his own way of solving them. Marie de Médicis
snapped him up and gave him a contract for not one but
twenty-one pictures, all to be about herself. The pay-
ment was to be 20,000 crowns. The pictures were to
decorate a new palace she was building. We are fortu-
nate in being able to experience just how twenty-one
pictures featuring one's hostess would strike a visitor:
they are all in the Louvre. As I have said, they are
greatly admired by practicing painters, even in these
days. The reaction of nonpainters to this type of mass
production has always varied. It will suffice to quote one
of them:

> At Antwerp we pictured—churched—and steepled
> again. As for Rubens . . . he seems to me (who by the way
> knows nothing of the matter) the most glaring—flaring—
> staring—harloting imposter that ever passed a trick upon
> mankind—it is not nature—it is not art—with the excep-
> tion of some linen (which hangs over the cross in one of
> his pictures) which, to do it justice, looked like a very
> handsome table-cloth—I never saw such an assemblage
> of florid nightmares as his canvas contains; his portraits
> seem clothed in pulpit-cushions.

Rubens' Flemish fondness for embonpoint is neatly
hit off by "pulpit-cushions," but then the observer was a

master of invective: he was Lord Byron (letter of May 1, 1816, to John Cam Hobhouse). Rubens buyers might agree with Byron that they did not know much about art, but they knew what they liked, and they liked Peter Paul.

They were led in this by a remarkable woman. Marie de Médicis was the daughter of the grand duke of Tuscany (of which state Florence was the capital) and by marriage became queen of France. Ten years later her husband was murdered, leaving a young son as the king (Louis XIII). Marie became regent and ruled France through her favorites. She was then at the top of the tree and was perhaps entitled to twenty-one pictures driving home the fact to all and sundry.

Unfortunately her son rebelled against her, slew her favorites, and seized the throne in 1617. But a mother is a mother, especially when she was Marie. She and he made up, and she was back on the top (or near it) till Cardinal Richelieu came to power and pushed her aside with a very firm hand.

Thus history. Marie had been so busy with it that she had not yet paid Rubens when Richelieu came on the scene; he canceled the deal. Peter Paul was not for a moment at a loss. Richelieu was an extraordinarily vain man. Rubens painted him in his ecclesiastical robes, filled with a quite extraordinary amount of "pulpit-cushions," and gave it to him. Richelieu let him have his money.

But all this took place in a foreign country, France, to which Marie had summoned him. Rubens' home base was secure. He was court painter to the Archduke Albert

and his wife Isabella, who, as we have seen, saw that he stayed court painter by paying up regularly. No doubt the fact that they knew he could walk off to France just when he chose had its effect in making Rubens a turning point in the story of the artist and his money.

Commissions poured in from all over Europe. In 1636 Philip IV of Spain wanted a lot of pictures, and in a hurry. Rubens drew the designs. Then he set a team of painters to slap away under his supervision. They were not just boys, as in Italy. These were competent painters, and Rubens distributed the work among them with a shrewd sense of organization. This man was good at robes, so robes he did; this at backgrounds, so he painted them all day long. And so on. The pictures (all as we would say today, with the Rubens touch) duly came off the production line: fifty-six large canvases in the astonishingly short time of fifteen months.

It is obvious that such a system would rouse comment in the minds of the good burghers of Amsterdam and in other prospective clients. From Cicero onward (and no doubt before him) the joy in.ownership in a work of art lay in being able to say "*That* is a Praxiteles" or "*That* is a Rubens," particularly if it is known that the price of such objects is high. If a cynic could say "But how *much* of it is a Rubens?" the pleasure is sensibly diminished.

Rubens had to prove that he was such a prodigy that he could really turn out this vast quantity of work—given, perhaps, a dog or a curtain or two done by other hands. If his signed output was phenomenal, he had to

establish the fact that he, Peter Paul, was the phenome-
non, not a squad of hacks.

He did so, magnificently. In the luxurious home he
built for himself, there was a studio. In this studio was a
balcony, where by invitation a prospective buyer could
watch the phenomenon at work. It was a sight worth
seeing, because one of Rubens' turns, so to speak, was to
paint great six-foot curves of glowing color without a
moment's hesitation.

The production chain gang was naturally not
present at these exhibitions. Rubens' assistants, on these
occasions, were the classical apprentices who sur-
rounded Titian or Michelangelo, the grinders of colors
and the handers of brushes.

But there were other performances to add, spectac-
ularly, to the artistic hoopla. While he painted, Rubens
also dictated letters to a secretary or had good books
read aloud to him Thus the awed spectator would go
away and pay his florins for a Rubens happily convinced
that a man of such titanic energy could easily paint every
inch of the canvas, and carve the frame too, if that took
his fancy.

It is much to Rubens' credit that, with all this
showing off, he remained a most agreeable fellow. His
charm was such that his royal employers not only used
him to paint pictures of themselves; they sent him on
diplomatic missions. Between 1621 and 1630 he visited,
in this capacity, Brussels, Paris, Madrid, and London.
While there are no diplomatic coups attributed to him,
he at least did not start a war, something that might
easily have happened in the life of so busy a man.

Naturally, while being a diplomat, he did something else. He put together one of the finest collections of antiques and other objets d'art in Europe. This showed his taste and discretion. He was also, for a successful artist, very modest, provided there was money in the modesty. You could not only order a painting from him by himself, he would sell you one by another artist just as willingly. It is difficult to imagine this happening today. It would be risky to spend one hour in the studio of, say, Juan Gris, looking at his work, and then casually to ask if he had any Dubuffets on hand. Rubens did not mind.

Nor was he one of those collectors from whose grasp it is impossible to wrest their choicer pieces, offer what you will. Rubens was sent on a diplomatic mission to England. The key to a proposed transaction (a dynastic marriage) lay in the hands of George Villiers, Duke of Buckingham. The duke, a social climber, wanted a collection of objets d'art such as it was the fashion for any gentleman to have. Rubens promptly offered him his whole collection at a rock-bottom price in order that the duke should push through the marriage deal. The duke accepted. The collection changed hands; the lady in question did not. It was a failure for Rubens, but then the duke was as great a charmer as Rubens, and, on this occasion it would seem, bigger.

But that was merely a passing cloud in the financial sunshine that bathed Peter Paul's life. His fame rang throughout Europe. From his time onward, patrons knew that if you wanted a picture by an artist with a name, you had to pay for it, and probably through the nose. This was a very good thing. He had also estab-

lished the fact that an artist could clean his fingernails and pass for a gentleman, and should do so.

This may not have been such a good thing. The question was fought out between two of the greatest geniuses in Italian art, Bernini and Borromini. It was fatal to one of them.

The principal paymaster of both was the Catholic Church in the person of the popes. To understand the quarrel we must go back somewhat in history, for the popes were as generous to Bernini and Borromini as the patrons of Rubens. The reason concerns one of the greatest artistic creations of Europe: St. Peter's and the great piazza in front of it. Curiously, because of electronics, this work of art is familiar to persons all over the world, even those who see no other. It is shown on television screens when popes die, or are elected, or when they greet the world each Easter with that magnificently indiscriminate blessing "to the city and the world."

St. Peter's had seen bad times. Run up rather hastily when the Roman Empire became Christian, it stood until the early Middle Ages and then began to totter. Its façade had, in all these centuries, been an unsatisfactory muddle patched up by various popes, but the inside had been sufficiently impressive—a huge version of a Roman court of law or basilica.

Then the popes left Rome, partly because of intrigues by the French and partly because of their disgust

with the citizenry of the Eternal City. The noble families had always brawled in its streets over papal elections, the See of St. Peter being a big financial prize. The popes moved to the French town of Avignon, where they built themselves a new palace and church in the Gothic style, a starkly beautiful building remembered nowadays by the name of a local wine, Châteauneuf du Pape refers to what Catholic historians term the "Babylonian Captivity" of the popes, a biblical (and polite) way of recording that the popes, while they stayed in Avignon, were in the pocket of the French monarchy.

But they came back to Rome (1376) in part due to efforts of an indefatigable letter-writer, St. Catherine of Siena. The Pope found St. Peter's—and indeed all Rome—in a sorry state of disrepair. His own palace, the Lateran, was an uninhabitable ruin, so he moved to a building on the hill on which St. Peter's was built, known as the Vatican, where the popes still live.

St. Peter's itself was just about to fall down. Cows and sheep grazed on the grass growing in the nave. Less picturesquely, wolves ate dead bodies from tombs broken open by looters. The massive walls leaned, in some places, sixteen feet out of the perpendicular. Nicholas V determined to pull the place down and build anew. That was the beginning of an uproar unparalleled, even down to today, in the history of the Catholic Church.

The trouble was money. Artists and architects could be made to wait for payment, as we have seen. But stonemasons, carpenters, bricklayers, and such had to be paid on the nail or they and their families would starve. Quarrymen, too, needed money. The popes could loot

the ruins of Imperial Rome and did so ruthlessly (the columns under the pope's balcony from which he gives his annual blessings are Roman spoils and sadly battered), but this could meet only part of the expenses.

Now sinners, according to the Catholic faith of the time, went to one of three places when they died. The good went to Heaven and the wicked went to Hell. It will be seen at once that this leaves out most of us—babies (who, until Sigmund Freud, were held to be innocent) and those of us who had been mildly bad in this life and were ready to be sorry for it. They went to Purgatory, where, after varying intervals of time for regret, they might be allowed into Heaven. They were helped along their path of redemption by the prayers of the faithful for them, here below.

There was another way. Prayers take take; time was money, even in the Middle Ages, and money could buy from the Church something called an indulgence. This, in English, is a most unfortunate term. The indulgence could also be applied to the buyer's misdemeanors. *Indulgence,* in our language, means a lay consent to something not altogether praiseworthy—overeating, illicit sex, and so forth. Outside Rome, the word came to mean a permission, bought at a price, to sin. It was never that. What it is today has been left open to question by Vatican Council II, which was unhappy about the whole thing.

It had reason to be, because indulgences brought Martin Luther down on the heads of the popes. Michelangelo's pope, Julius II, was devoted to the rebuilding of St. Peter's, which was dragging on desper-

ately for lack of money. He stepped up the sale of indulgences, for what was after all a good cause. Good causes have notoriously been the meat and drink of businessmen out to make an easy dollar. It was so with one Texel, a Dominican monk who, aided and abetted by the Archbishop of Mainz and Magdeburg, pushed the sale of indulgences to excessive lengths.

Martin Luther, who was also a monk—an Augustinian, between whom and the Dominicans no love was lost. He saw ninety-five reasons why the sale of indulgences was a scandal. While he was by no means a man who shunned striking gestures that brought him publicity, the one by which he is known to every schoolchild was not among them. He nailed the ninety-five arguments (or theses) to a church door in Wittenberg. This was pure routine. It meant that he, as a theologian, was ready to go into debate with any contrary theologian. Their debates were often entertaining, sometimes ending in broken heads. In Luther's case, it split the Church.

In 1530 Luther drew up the Confession of Augsburg. There were now two versions of the Christian faith in existence, the Catholic and the Protestant. The Protestants had little use for artists, except to save the souls of those artists who wanted them saved. As patrons, the Protestants were, in early years, negligible. Holy pictures were removed from churches, statues were considered idols, and as for architects, the stricter sects used them only to make sure that the roof would not fall in upon worshipers, unless (in the case of Calvinists) it was predestined to do so, in which case there was nothing to be done about it.

The wrath of the first Protestants was directed against Rome. At the beginning of the sixteenth century it was a squalid city, with narrow, insanitary streets, rat-infested medieval houses, and moldering ruins. Although it was the seat of the papacy, its moral vices were notorious. The situation was summed up in a famous story, much quoted. A Jew was brought by a Christian to Rome. After a year, the Jew became a Christian. Asked by the astonished citizens why, he replied that if God permitted the things to go on that he had seen, then Christianity must be the true faith.

The pope, acknowledging that there was some truth in Protestant attacks, summoned a council. It sat at Trent for thirty-five years. Luther's breakaway is known as the Reformation. The decrees of the Council of Trent began the Counter-Reformation, the biggest financial boon to artists since Constantine had declared the Christian faith respectable.

The Council of Trent approved of Art provided it conveyed a Lesson, the Lesson being that the Catholic Church was right. Art was therefore to be propaganda. Today, untold billions are spent in propaganda of every sort. It is an expensive affair. The popes had learned their lesson. Artists cost money. They loosened the purse-strings, and artists, leaping to grasp the opportunity, turned Rome into what it is today, the world's most beautiful city. The medieval buildings were torn down, great streets driven through the city to center on St. Peter's, tumbledown churches were splendidly rebuilt, domes sprouted everywhere. The relatives of each successive pope joined in with a will and built themselves

huge palaces. While these did little to propagate the faith, their great façades and beetling cornices at least showed the pilgrim that the pope was a man to be reckoned with, a fact the Protestants hotly denied.

In all this, the artists and architects were greatly helped by Ignatius Loyola. A soldier by profession until he turned saint, he knew nothing about art whatever. But he had the brilliant notion that the humble worshiper, poor as he might be, when he went to church should be surrounded by as much splendor as the relatives of the pope. He should have marble and gold, pictures and statues, painted ceilings and gilded stuccoes. The Protestants agreed that a church was a dwelling of God, but maintained that He had no particular aesthetic enthusiasms. Loyola and his followers, the Jesuits, said a church, as well as being His dwelling, should be the reception hall for His worshipers, no expense spared.

This bonanza for artists is known as the baroque. Baroque is what the artists did with all the money—and there was plenty of it, for the Catholic Church, embattled, could call upon the faithful to defend their religion with their purses; in a time of war, as lay governments know, taxes are always easier to collect. When the Protestants had tired of knocking down statues and stripping churches to the bone, they came to a conclusion that still affects our taste today. They decided that the Gothic style was the only holy one. The perpendiculars took one's thoughts up to Heaven. The reception halls of the baroque, they maintained, kept them on a lower level—sometimes on a *much* lower level. The

Whore of Babylon, as unreconstructed Prostestants of
the age called the pope, would naturally have a flashy
decor. The baroque was therefore considered sinful.
The leading architect of the Victorian age, an English-
man called Pugin who believed in the Gothic, was shown
the greatest monument to baroque taste in Rome, the
finished St. Peter's. He fell on his knees and thanked
God. Rising from them and dusting his trousers, he
explained that he had detected a crack in the dome.

In the next chapter I shall describe how the artists
spent all the money that was poured over their heads.
But I find that the sentiment against the baroque still
lingers, and some readers may think they could have
done better with it. The word *baroque* has come to imply
extravagance in both style and expenditure. In fact, it is
merely a development of the ideas of the Greeks and
Romans. Before the popes carted off columns and
marbles from the ruins, architects measured them with
loving care. They imitated the Romans in all their
buildings. I have spent years in St. Peter's. There is not a
single feature in it that cannot be traced back to classical
times. Even the most elaborate decorations are derived
from the paintings on the ceilings of the Golden House
of Nero.

Having thus defended Bernini and Borromini from
the charge of being wild and woolly, I shall tell how they
fought, Bernini because he loved money to distraction,
Borromini because he was a strange, new phenomenon,
an artist and a genius who despised it.

The Rivals: Bernini and Borromini

Giovanni Lorenzo Bernini (1598–1680) was the product of the Counter-Reformation—and a remarkable father. Pietro Bernini was a sculptor, a workmanlike person who could chip away at marble with the rest, but was completely uninspired. In a moment, I shall excuse his failings as an artist, but first we must praise his outstanding merits as a father. From the age of twelve (or perhaps sixteen—the date is disputed) the son Lorenzo showed by his first paid commission that he was a far better sculptor than the father. Everybody said so. Pietro did not beat his son for it, or quarrel with him, or sulk. He had taken him to Rome, and there money was to be

made: if little Lorenzo could earn it, so much the better—it was all in the family.

In a few years it became clear that not only was Lorenzo better than his father, he was the best sculptor of his generation, in fact (again everybody from popes downward said so) a genius. Yet still Pietro liked his son. Among artists, that is very rare. Lorenzo reciprocated by loving and even admiring his father for all the old man's life, which ended when Lorenzo was thirty-one and the most celebrated young artist in Rome. Lorenzo's filial devotion to his father and his frigid, awkward sculptures is one of the admirable things about his character. There are not many others.

Perhaps he saw that his father was not to blame; rather, the fault lay with the great Michelangelo. If one studies for any length of time such sculptures as his *David* or his *Moses* one has the overwhelming feeling that if the thing is to be done at all, this is how to do it, and there are no two ways about it. Michelangelo's successors had that sensation to a degree. It lasted a long time, and it is possible to maintain that not until Rodin beat his clay furiously about did the feeling disappear from the history of art.

The successors to Michelangelo, in painting and in sculpture, are known as mannerists, but this is a made-up name, smelling of the oil lamp. The mannerists were too various and too talented in their own individual ways to be lumped together. One thing they all shared, however: timidity, brought on by the contemplation of the Master's work and his *terribilità*.

Young Bernini was not in the least timid, and he

was not awed. He did not look back to the past: he kept his eye firmly fixed on the present, to say nothing of the main chance. Two heads illustrate him to perfection (they are in the Spanish embassy in Rome and unfortunately are not easily seen by the public). One is entitled *The Damned*, the other *The Saved*. Both (it was said at the time) were likenesses of the artist himself. *The Damned* stares down into Hell with an expression of the utmost horror. The other looks up into Heaven. The first shows that Bernini could be quite as terrifying as Michelangelo in his *The Last Judgment*. The second shows the saved soul looking up not so much at the Ineffable Vision as looking out to see if it is going to rain.

The second, as Bernini knew quite well, was exactly in tune with the spirit of the Counter-Reformation. While Calvin and the Protestants were preaching the reality of hellfire, the successors to the Council of Trent, while tidying up the Catholic faith, were anxious to reassure the truly faithful (those, that is, who went regularly to the splendid new churches) that there was mercy and forgiveness around the corner. The Jesuits even lightened the pains of the confessional, and the Protestants accused them of finding a clever way around sin itself. This was perhaps harsh, but they did make admirable confessors to the mighty and the powerful who found themselves, for reasons of state, in a moral jam.

Bernini perfectly fitted this new world. Though not handsome, his features were refined and his figure elegant. His manners were smooth; he had wit that did not wound—and he had a sense of money people who

dealt with him in his later life called downright avarice.
He could also make his chisel obey him as though it were
a living animal, trained to obey his slightest command.

The young man soon found a patron, the best in
Rome. Cardinal Borghese ordered a bust of himself.
When it was finished, the cardinal came with his court
and was respectfully entertained by Bernini. When the
sense of a great occasion was thoroughly aroused in
everyone, Bernini swept away the cloth from the bust.
An exclamation of dismay broke out from the cardinal.
The bust was a superb portrait, but the marble was
flawed. Bernini, expressing utter mortification, said
that, at no extra expense, he would do another at
lightning speed. A bust normally took several months of
work. Bernini said he would have a new one in less than
a fortnight. There were more exclamations, this time of
wonder. Bernini was as good as his word. The bust, a
stupendous production, is to be seen in the Villa
Borghese today.

Any modern publicity agent, while admiring Ber-
nini as a talented forerunner, would ask why, when
the young man found that the marble had a disfiguring
streak, he went on carving the bust until it was finished
down to the last lock of hair. But as any modern
publicity agent knows, with a really good "sell," people
do not ask those questions.

And it had been an excellent sell. Bernini had won
his patron's heart and his purse. He went on from
lucrative triumph to lucrative triumph for the rest of his
long life. He also never gave up his liking for the
spectacular selling line. The one he made for the famous

fountain in Rome's Piazza Navona is the most entertaining in the history of the baroque.

When Bernini was at the height of his fame, he received the commission to make a large fountain in the middle of the vast Piazza Navona. The reigning pope, Innocent X, was a little tired of Bernini's flamboyant lifestyle and success. He preferred a much more modest genius, but popes, in spite of being infallible, cannot always have things their own way, and in this case Bernini had enough influence to get the job.

Bernini never did anything badly, and the fountain was no exception. Four lounging figures, owing much to the classical Romans, represented the four major rivers of the world. A cave sheltered a lion, and on top of the lot was an obelisk. The whole composition, rather fretful when dry, was designed to be bound together by gushing streams of water.

The pope duly turned up for the inauguration. Speeches were made; music was played, prayers intoned, and Bernini gave the signal for the waters to flow.

They did not. The pope turned away in disgust. The cardinals were haughty, the artist shattered with dismay. Barely holding back his tears, Bernini, head bowed, followed the retreating ecclesiastical procession.

A shout from a workman; the noise of water. From a hundred cunningly devised orifices, water poured forth. The pope turned back. The cardinals turned back. The people cheered. Everybody was very, very happy. Bernini had put on one of his best shows.

This extraordinary master of the chisel and public relations was, in fact, known to the public not only for

his sculptures and his architecture but also as a theater producer of astonishing masques, or—as we would call them—plays with music. He wrote the book, designed the scenery and costumes, invented the machinery that brought gods and goddesses up out of pasteboard clouds, and, on occasion, even took part as an actor. The shows were, perhaps, not very exacting to put on. The text called for nymphs, satyrs, tritons, fauns, gods, and goddesses to enact some classical tale that, at the climax, turned out to be an enormous piece of flattery in verse of the man and his wife and family who had paid for the entertainment. We would not like such an entertainment today. But no expense was spared and that usually, in the world of entertainment, leaves the audience in a happy mood. Unfortunately, none of Bernini's scripts or designs for these masques have survived, so we cannot judge. But on the proceeds from the shows and his sculptures, he lived in a palace, had a coach and horses and a flock of servants, entertained lavishly, and dressed as well as the most fashion-conscious courtier.

One example of the sort of thing he put up in lath-and-plaster to astonish the public has come down to us. The great baldacchino, or canopy, that shelters the papal altar in St. Peter's. This, too, is familiar on television. It has enormous twisted columns of bronze and young angels perched precariously on the roof.

I once was able to study the baldacchino in great detail because it was being cleaned by the *sampietrini*, the workmen responsible for the maintenance of St. Peter's. I was even able to see the canopy close. I talked to the *sampietrini*. They did not call the baldacchino by its right

name. They called it *la macchina*, the machine. This is what the settings for Bernini's shows were always called, and this solemn construct to shelter the heads of pontiffs looked, said contemporaries, exactly like one of them. Hence, down the decades has come its name among the men whose job it is to keep it clean.

Bernini was the perfect artist for the Counter-Reformation in every way. A rake when young, he quickly reformed, married, and raised a large family. He was devout, but not boringly so. He believed firmly with the Council of Trent that Art should always have a Lesson. This he called the *concetto,* the concept. You could say, looking at his sculpture: "That's very pretty and awfully well done," but he much preferred the spectator to say something like "I observe that Truth—the figure on the right—is trampling upon Heresy. Splendid! Splendid!" As an example, the figure of the True Faith on the tomb of Pope Alexander VII in St. Peter's has her left foot on a representation of the terrestrial globe. It is firmly planted on England, the home of the Protestant split.

One final glimpse of Bernini at the summit of his glory, with more money pouring into his coffers than into those of cardinals themselves, will suffice.

Queen Christina of Sweden is probably better known to the present generation as Greta Garbo, who made a film about the more acceptable aspects of her very strong character. The queen of a firmly Protestant country, she habitually wore breeches and converted to Catholicism. She abdicated and headed for Rome. The pope knocked down a bit of the ancient wall of Rome

and built a special arch to welcome her (now the Porta del Popolo). He then spent the rest of her sojourn heartily wishing the lady would go away. The breeches were not so bad when she wore them: the trouble began when, it was rumored, she did not. Her sexual morals, or lack of them, became the gossip of Rome. She was also a bluestocking, the name for a woman of intellectual pretensions who forces them down everybody's throat.

It says a great deal for Bernini's success that among the first things Queen Christina did was to pay a call "of honor" to Bernini's studio. Bernini had been among the gorgeously dressed papal courtiers who had waited at the new city gate. When the queen arrived at his studio, she found him absorbed in chipping at a piece of marble and dressed in a workman's gown that stank of sweat. Bernini bowed slightly and went on chiseling.

The queen, sizing up the situation, advanced, knelt, lifted the hem of the smelly garment, and kissed it. Who had upstaged whom in this encounter it is difficult to say. Both, at least, had proved themselves master of the art.

Let us now turn to the shadow on Bernini's glittering lifestyle—Borromini.

Borromini (1599–1667) and Bernini were born within a year of each other, but there the resemblance ends. Bernini was born into an "artistic" family, as we would say nowadays; Borromini was firmly working-class. His father was a stonemason.

The profession of stonemason has almost disap-

peared from the world, like that of the cobbler, but both had well-known characteristics. The cobbler was a philosopher, content with his lot but inclined to be whimsical; the stonemason was stubborn, loyal, and true. He was also extremely reserved. The Freemasons use the symbols of the trade in their semisecret rituals.

In his youth, Bernini was a prodigy. Borromini was just a stonemason. Bernini used his chisel to show off his genius; Borromini used his to do as the architect told him. Bernini was quite content with being what he was—a creative genius. Borromini yearned to be an architect. Bernini was never a poor boy. Borromini was.

They met in St. Peter's. The great church was growing fast, but all day long it was swarming with workmen and filled with dust from the stonemasons. The noise and confusion was tremendous and exciting and through it all walked Bernini, surrounded by assistants, attended by prelates, and giving orders everyone leaped to obey. He had been given the task of completing the decorations, and the inside of the church looks as it does today because of him.

But, of course, he had other things on his mind—theatrical shows, parts to write and learn for masques, portraits (he was also a painter), and being a gentleman at court, a time-consuming duty. He had need of people who could take over from him when he felt tired or was too busy, competent artists who would not ask too much of that other love of Bernini's life besides celebrity, money.

One day, amid the noise and the dust of St. Peter's, a stonemason showed him some architectural drawings.

They were not like the impersonal blueprints of today, which consist (as young architects woefully admit) in the cunning disposition of drains and et ceteras in big boxes. They were free hand sketches, almost scribbles, harmonious and elegant solutions of complex problems, like the notebook of an advanced mathematician. Bernini was impressed by the sketches of Borromini and promised him work as an assistant-architect. Borromini's dream had suddenly become true. It would have been the beginning of a happy life, except for one thing. Bernini saw instantly that the stonemason had as much talent as he had. Like every financially successful man, Bernini knew that the art of being at the top is to stay there. He gave Borromini jobs to do, but mainly to keep an eye on him.

Besides all the other things, Bernini was a master at keeping any possible rival down. There was no other way of making sure of one's income. Payment was at the whim of popes and cardinals. Most of them—with a rare exception like Cardinal Borghese—know nothing about art except what they were told. Then, as now, buyers of art can hold few names in their heads: "Matisse, Chagall, Moore, Lipschitz, and that man who made such a stir with his show, What's-His-Name?" Art dealers know this very well. Bernini, his own (and very successful) art dealer, knew it. One of the results was that he managed to obscure to this day the name of a sculptor quite as talented as he, Algardi. There is no question that he was every bit as good a sculptor as Bernini, but he lived his life as the great man's assistant. Another, Mochi, who rebelled, was ruined. Bernini attacked his reputation hip

and thigh, and he died poor and broken-hearted. A palace, coach and horses, servants and fine clothes, cost money; a fool and his money are soon parted, and Bernini was no fool. After all, there is no quicker way of losing a patron than pointing out that some other artist is as good as, or even better than, you are.

But in Borromini, Bernini had stubbed his toe against an entirely new type of artist, one who was completely devoted to his art and who gave not a damn for the world and its opinion of his way of life. He was the sort of creative genius who has a profound attraction for late adolescents of all periods—the rebel, the misunderstood, the odd man out at parties and the family table, the brooding nobody who reaches the pinnacle of fame and it does not spoil him in the least. Borromini was the first of a whole host of heroes to the young: Van Gogh cutting off his ear, Gauguin walking out of it all and dying on a tropic isle, Rudolfo in *La Bohème,* Modigliano trying to sell his drawings to get enough money to buy a meal, the Artist, in a word, with the capital A. Most of Rome thought Borromini potty. But that was to be expected from the bourgeoisie, and the popes came from the middle classes, however grand their relatives became.

Only in recent years have we been able to piece together a picture of Borromini as he really was, thanks to the patient work of scholars, and one point must be made at once. Borromini despised money, as I have said. But he made it, and he kept it. Far from having to sell his worn old jacket to buy medicine for the dying Mimì, he left a will in which his nephew was his heir. This

nephew, Bernardo Castel Borromino,* having obeyed
his uncle's order that he get married to the woman of his
uncle's choice, lived comfortably on his inheritance for
the rest of his life.

Borromini was a tall, robust man with an aquiline
nose, not much of a chin, and strikingly melancholy eyes
surmounted by a broad but furrowed brow. His hair was
long and untidy, but that may have been a wig. His dress
was eccentric.

Bernini and all Rome that mattered dressed in the
French fashion, with plenty of color and ribbons and
bows. Borromini dressed in the Spanish style (which had
gone out years before), in severe black. He would have
looked very strange at a social gathering, but he never
went to them. He stayed at home, seeing no one but a
faithful assistant. Here he concentrated on his art to the
exclusion of everything else. He collected books on
architecture with such avidity that it is estimated that he
must have had the most complete collection in the
world. He kept them in heaps and piles, in drawers and
on tables, mixed up with etchings and his own designs.

Bernini was the Renaissance gentleman, able to do a
hundred elegant and amusing things. Borromini also
had a number of skills, and they were not amusing at all,
especially to those who worked under him. "He him-
self," says Fra Giovanni di St. Bonaventura, who wrote
about him, "directs the bricklayer's trowel, teaches the
stucco-worker how to use his knife, the carpenter his

* Borromini's real name was Castellani. His adopted name is spelled
in the documents with either an *o* or an *i*. I have kept the *o* when it
refers to his nephew.

saw, the stonemason his punch, the slate-worker his hammer and the blacksmith his rasp." Woe betide the workman who did not learn the lesson of the master. One stonemason had spoiled a block of marble in a thoroughly careless and ignorant manner. (Apparently he compounded his crime by spitting on the stone.) Borromini instantly summoned the other workmen and had the man beaten up. The unfortunate workman died of his injuries.

For all that, Borromini found patrons and commissions, so extraordinary were his talents. He did not do particularly well at first; the papacy was all for Bernini. But popes come and popes go. Innocent X preferred the somber ex-stonemason to the worldly Bernini. It was a bold step for a far from bold pontiff. Innocent X was entirely under the thumb of his sister, Donna Olimpia. She preferred Bernini and she shared his taste for money. She was so avaricious that when poor Innocent died she let his body lie for days without a coffin because she refused to pay for one. Bernini got the commission for the fountain in the Piazza Navona by making a model of it in solid silver, leaving it in a corridor of Donna Olimpia's apartments, and never asking for it back.

The two artists were now deadly rivals. Bernini maintained that it was he who taught Borromini all about architecture, gave him jobs to do in St. Peter's, and told him how to do them. Borromini did a great deal of work. The magnificent niches framing the giant statues around Bernini's baldacchino are by him. Borromini replied that Bernini was a total amateur as an architect

(in a sense, both were, neither having trained as one). He complained bitterly that Bernini took the pay and left him the work. "I do not mind him having the money," he is recorded as saying, "but I do mind that he should enjoy the honor for my hard work."

All the evidence that has come down to us bears out that this was a genuine, heartfelt statement. Borromini had little interest in money but a consuming thirst for artistic fame. It came to him, to Bernini's vast annoyance, with the little church of San Carlino at the Four Fountains in the Via Quirinale.

The site was small. The story goes that as a piece of bravado, Borromini said he would build a church that could fit inside just one of the great piers that hold up the dome of St. Peter's, and yet it would seem spacious. This story cannot be true. I have checked it. I have been *inside* one of the piers by a passage that is never open to the general public. A huge hall has been hollowed out of it, quite as big as the average parish church and which in fact contains a model of an abandoned design of St. Peter's, large enough for one to stand inside. Borromini must have known that, for his fellow architects, this would be an empty boast.

Nevertheless, the site was cramped and awkward. Down the road was a far better position with more elbow room—and there Bernini raised his masterpiece, the Church of Sant' Andrea. The modern tourist visits this as a duty. He is inclined to pass by the little San Carlino. But if he goes inside, all is wonder.

Borromini, like all baroque architects, stuck faithfully to the classical examples from ancient Rome for all

his details, the pieces of his compositions. But he put them together in a way no one had ever seen before. Roman architecture is static. It sits firmly on the ground, immovable, solid, permanent. The façade of St. Peter's is as solid as the Great Wall of China. San Carlino flows. The eye travels, beguiled, from detail to detail, from cornices to windows, from windows to ceiling with its extraordinary honeycomb of a dome, from ceiling down to the central altar. There is not a moment of disharmony, nothing to jar and hold one up, yet nothing fixed in its place. The whole design is on the move.

The intelligent tourist of those days by no means passed San Carlino by. All Europe was in a fever of building, and Rome set the style. People came from Germany, France, Spain, England, Holland—even, we are informed, from India—to marvel at Borromini's originality. Bernini had a rival he could not put down.

Besides, things were going wrong for the man who did everything right. All those millions who see the front of St. Peter's on television must have noticed how heavy the long, level line of the roof is. Cathedrals usually have towers. Bernini decided to give St. Peter's a couple. Where the clockface is now, he built a spire. No doubt because he was so busy with other things, he did not check the foundations sufficiently carefully. The weight of the tower began to crack the façade. Had not the tower been hastily pulled down, part of the front might have crashed to the ground. Little towers on top of things were Bernini's weakness. He wanted to put two on the severely classical façade of the Pantheon. The

Romans promptly dubbed these "the donkey's ears," and they were never built.

All this—and Borromini's galloping fame—clouded Bernini's professionally sunny temperament somewhat. He willingly listened to anything bad about his rival and smoothly improved on it. An important patron had remarked that Borromini's work was almost *Gothic,* it seemed to depart so much from the classical models. Bernini improved on this. *Gothic,* as we have seen, was equivalent to *Protestant.* Protestants were heretics. Bernini, smiling his public smile, remarked that in his opinion it was better to be a bad Catholic than a good heretic, leaving nobody in doubt that he meant that Borromini was the heretic, a character smear in Counter-Reformation Rome. Borromini, by temperament a moody man, grew morose.

Commissions poured in. Even while San Carlino was still building, he was appointed architect to one of the biggest projects in the city. The Counter-Reformation had thrown up many men who aimed to enliven the Church in any way they could. Philip Neri, later a saint, believed in music for the people, just as the Jesuits believed in marble halls. His group had an enormous success. They planned to erect an oratory (that is, a church) and an attached monastery. The ruling body, called the congregation, had the money. In Borromini they had the architect. All should have been well but it was not. The trouble with an artist who notoriously does not care for money is that he might spend it carelessly: he might even *waste* it. The good oratarians decided to

keep a firm hand on what, generations later, was to be known as the "artistic temperament."

Borromini's mighty grumble thunders down in a document he caused to be written about himself. He addresses us as "Benign Readers." He asks us to consider with sympathy what he had to put up with from that congregation of singing clerics: "I had to serve a Congregation consisting of such timid minds that I was tied hand and foot as far as decoration goes and in consequence I often had to obey their wishes rather than the demands of art."

The façade of the monastery, one of the loveliest ever built, seems to breathe under one's gaze, so cunning are its curves. But, admiration over, the spectator is certainly conscious of its bareness. How many carved swags, or angels' heads, or elaborate capitals Borromini had to forego, we shall never know. The congregation, complains Borromini, kept the strictest accounts "and if I exceeded even by a little the rules laid down for me, I had nothing but endless complaints."

In the end he resigned. He was the sort of artist who could only work for a patron who understood what a genius he was. Then he worked very well. The pope had appointed a great admirer, Vittorio Spado, as superintendent of the works for restoring St. John Lateran, the pontiff's church when he acts as the Bishop of Rome. There was no trouble. The work proceeded at a lightning speed. Harmony reigned. The genius was happy and contented. The vast nave of St. John Lateran can be seen exactly as Borromini left it. It is quite remarkably

dull. In fact, very few people would even guess that it was by the great man.

Borromini needed conflict; that much is clear from the interior of St. John Lateran. He soon got it in full measure. Opposite Bernini's spectacular fountain in the Piazza Navona was a small church built over a supposed Roman brothel. Here St. Agnes, an early Christian, had been dragged for the purpose of being raped, a theological argument not among those of Luther's ninety-five theses, but one the Roman authorities thought would convince her that her religious beliefs were wrong. Miraculously, her hair grew instantly to cover her nakedness, and she had to be dispatched by more hasty methods. In the Counter-Reformation it was decided to rebuild her church with the utmost magnificence.

Donna Olimpia had the piazza in the hollow of her hand. She chose Carlo Rainaldi for the job. But her brother the pope died and, by steps we need not trace here, the commission went to Borromini. By this time the moodiness had increased by leaps and bounds. He was sure that Bernini was persecuting him and this led him to see conspiracies against his work everywhere. This is common among failed artists (perhaps obligatory if they are to remain sane) but rare among men like Borromini, who had attained eminence. Perhaps he had memories of his own humble beginnings as a stonemason and the tricks his companions had been up to. At any rate, he formed the opinion that the workmen on the project were against him.

He took action: he simply did not turn up in the

mornings. The workmen waited for his orders; none came. They waited for their wages, for which Borromini had the money to pay them; they did not come either. To make matters worse, sometimes Borromini did turn up, but in his own way. Piazza Navona was famous for its bookstalls. While the workmen gathered on the road or on their scaffolds, they saw Borromini, easily recognized because of his unfashionable black, strolling at his ease, browsing among the books and chattering with the stall-owners. It was too much. The workmen complained. It made little difference. Borromini resumed giving orders, but contradicted them the next day. Some workers walked off the job. Others appealed to the law.

We have seen how the first great artists were members of a powerful guild, or trade union, that kept them under its thumb. Now the station of the artist had risen so far that he could do almost as he liked. But not quite: the workmen sued Borromini for their wages, as well as for neglecting his duties, and Borromini was dismissed. Carlo Rainaldi was called back, and it was he who finished the church.

One of the statues of the river gods on Bernini's fountain faces the completed church and has its hand raised in a gesture that could be interpreted as one of horror. Visitors are invariably regaled with the story that this was Bernini's revenge. It is a pretty story, but, apart from the fact that the façade has little of Borromini's style in it, when the fountain was opened, the church was a mere hole in the ground. But wrong as the story is in its facts, it is right in its spirit. The two men detested each other more and more, the older they grew.

The upset of his dismissal inspired Borromini to
turn out, elsewhere in the city, some of his finest and
most daring work. But his sense of persecution grew
apace. He became even more withdrawn and gloomy.
He grew ill and a doctor was called. Since there was no
obvious malady to diagnose, the doctor, much as any
medic today would do in dealing with an artist, said that
Borromini was overworked. He privately told the artist's
assistant (who also acted as a servant) not to allow his
master a candle at night.

Night came. Borromini called for a candle. The
assistant refused to give him one, and left. A tremen-
dous despair overcame his master. It was a trivial
incident, but it is always such little things that finally
convince a person of Borromini's temperament that the
world—represented by Bernini—was not only against
him, but would win in the end.

He took his sword, fixed it firmly, and flung himself
upon it. The sword entered his chest and came out at his
back. Borromini fell from his bed to the floor. The noise
brought his assistant running, and he found his master
still alive and perfectly conscious.

The law demanded that a notary should take, if
possible, a statement from the dying man's lips. Bor-
romini supplied one, perfectly calm in manner and
perfectly cogent. He made his will, distributing his
collection to such friends as he had, and leaving his
money to a nephew. Then he died, at peace with the
world, except for Bernini.

As for that archrival, the path was cleared for him. His triumphs continued, unshadowed, for a while. As for money, the king of France, the *roi soleil* Louis XIV, even paid him an annual sum of money on the mere promise he would one day work for him.

Bernini, now a man in his seventies, did an equestrian statue of the king. He sent it to Paris and Bernini knew his first and last humiliation. The king detested the thing and everybody in his court agreed. He ordered it banished to the most remote part of the gardens of Versailles. It is still there and if you are prepared to walk a whole mile of garden path (and provided the gendarmes will let you) you can see it. I like to think that sometimes the ghost of Borromini walks that mile, looks at the statue, and smiles—if, of course, he ever smiled.

The Fakers

"Woe to you! you thieves and imitators of other people's labors and talents. Beware of laying your audacious hand on this, our work."

This was the rather vague curse laid by Albrecht Dürer on people who copied his popular engravings and sold them as his. It had as much effect as the phrase "the Law punishes forgers," which is neatly engraved on Italian banknotes and is as neatly copied by forgers. If people call bits of illustrated paper money, there will be forgers. If people pay large sums for the work of an artist, there will be fakers. In a way, the whole tribe of

fakers that grew up after the Renaissance is proof that the artist was no longer an artisan: he was making real money.

Here and in Chapter 11 I shall be presenting a brief anthology of fakes and fakers, but first let me air a moral problem. What are we to think of a really good faker? Naturally he lacks the touch of creative genius; but then, from time to time in their careers, so have creative geniuses, but they plod on, very like the faker, for the sake of their wives and families and mistresses. The faker cheats the collector, the director of the museum, the auctioneer, and cheating is not nice. But do not the collector, the director, and the auctioneer set up to be experts? Do not they claim to have better taste and sharper discrimination than us lesser mortals? They do. And when they step on a banana skin and buy a fake, is it tragic? Or funny?

I do not venture to answer that question myself, but in what follows I shall put some fakers on trial and let the reader be the jury. I can promise some surprising witnesses for the defense.

The first defendant is so awesomely famous I think the court should stand as he enters. He is Michelangelo. Please be seated. The trial will proceed.

When he was a young man Michelangelo's patron, Lorenzo de' Medici, was by far the most cultivated member of that banking family. At that time a great deal of digging was going on in Rome to find antique statues. They were greatly prized by collectors. It was unfortunate that those that were found were usually badly knocked about. During the Middle Ages, statues were

considered idols and the work of the Devil. Hundreds were ground up for making lime. Others survived in a mutilated condition, lacking heads, or arms or legs, and in particular noses. It was said for a long time by collectors that any Roman head that had a complete nose was sure to be a fake. That is not quite true, but, in those days, it was a good rule of thumb. A complete, undamaged Roman statue was obviously worth a great deal of money.

Michelangelo made one, a sleeping Cupid. That is to say, he took marble and a chisel and made an "antique." I think the defense will rise at this point to say that he did it not to deceive but to enlighten. He wanted to show that he was as good as any ancient Roman.

His patron Lorenzo de' Medici agreed heartily. He also suggested to the young Michelangelo that he bury it a bit in earth and then dig it up, when it would look even more antique. Further he suggested (being the scion of bankers and having a sense of money in his blood) that Michelangelo send it to Rome, where it would fetch a very good price. Michelangelo agreed and did as he was advised. But (and here we once again accept the argument of the defense) he did *not* bury it in the ground.

He sent it, as an antique, to one Baldassare di Milanese, a dealer in old statues in Rome. Baldassare did not actually disbelieve Michelangelo, but he took the precaution of burying the Cupid in a vineyard and leaving it there until it got a nice coloration. Perhaps he thought Michelangelo had scrubbed the statue too heartily; perhaps he did not. We do not know. What we do know is that when Baldassare finally dug it up, it was

so convincing that Cardinal Riario di San Giorgio, a prelate of taste and learning, snapped it up as a genuine (and undamaged!) antique. He paid two hundred gold ducats for it. Baldassare sent Michelangelo his share of the deal.

But the cardinal grew suspicious. For one thing, the Cupid was remarkably complete; for another he had heard of one young scamp Buonarroti who, it was said, could do anything the Romans could do. He was extremely tactful, as became a son of the Church. He sent an emissary to Florence to talk to the remarkable young man.

The emissary was even more tactful. He lightly discussed art and the antique with Michelangelo, and Michelangelo drew a hand as good as any classic model, and also showed him a bust. The emissary then asked Michelangelo if ever, by chance, he had sculpted a Cupid. Michelangelo said yes, he had. The emissary thanked the young man for his kindness and courtesy, complimented him on his talents, and then rode post-haste back to the cardinal.

The cardinal's suspicions were confirmed. He summoned Baldassare and told him to take back the Cupid and repay the two hundred ducats. He was not particularly angry. He did not admire the cheating dealer—he insisted on his money—but he took note of the young man who could carve a fake which had, for a while, deceived *him*, the cardinal, noted to everyone for his taste and discernment. Later, when Michelangelo came to Rome, he befriended him.

At this point we must take note of a curious

circumstance in the business of faking. The buyer who detects the fake is rarely cross with the artist who perpetrates the fraud. A connoisseur's reasoning goes this way: "It must be a very good fake or I would have instantly detected it. It has deceived everybody that I have shown it to, including that pompous ass Professor So-and-So who thinks he knows everything. But I *did* detect it, which is a feather in my cap." Of course, if it is the bumptious professor or critic who first notices the fraud and announces it to the world, this is embarrassing. That, fortunately, does not often happen. As we shall see, the art world is a close-knit affair. The expert takes a fee from the collector to authenticate a work of art, or not, as the case may be. He also takes a fee from the dealer who may have his suspicions.

Now an art historian prepared to shame a multimillionaire is a rare bird. They have existed; they are the stuff of which martyrs are made, and that is how they usually end up. The thing is usually done quietly. Over the decades a whole vocabulary of half-truths has grown up so that nobody's feelings are hurt. We shall learn of a few when we come to modern times.

But to return to the Renaissance and Michelangelo, there was a type of faking that was perfectly honorable and above-board. We have seen that most of the Roman statues being dug up were mutilated. The connoisseurs of the time saw no merit in this state of affairs. They wanted noses put back and limbs restored, so that the relic would be presentable, particularly to popes, cardinals, dukes, duchesses, and other guests who, in matters of art, were often as ignorant as mules.

Now, if the Director of the Louvre decided to fit the Venus de Milo with a brand-new pair of arms there would be a world outcry. We value the works of antiquity as monuments of history. A large number of cultivated people, if put against the wall, would admit that they did not particularly like the Venus de Milo, and the innumerable little copies of it that have been made have been given a touch or two to make her charms acceptable to the current taste in women.

The men of the Renaissance and the baroque, however, thrilled to the sheer beauty of the art of the ancients. Human faces—real ones on living people—are often attractive. The perfect body is much rarer. So rare, indeed, that the connoisseur and artists of those times agreed with the ancients: the perfect human body did not exist. It had to be invented. This such sculptors as Polyclitus did. There was found a statue of a youth, wrongly thought to be Antinöus, Hadrian's lover. Bernini and others measured it in detail and these proportions, not to be found in nature, were considered an ideal every artist should follow. Michelangelo's muscular men were not taken from life. They were the result of his intensive study of a torso of the god Hercules still to be seen in the Vatican.

Plainly, if ideal beauty was sought in a work of art, the mutilated remnants must be "restored"—made whole according to the classic rules of proportion, stance, and modeling. So far, so good: we moderns might accept such a practice, though we would not indulge in it ourselves. The trouble arose when the

collectors insisted that the "restoration" should be so good that no one would notice it.

The restorers were equal to the task. The magnificent Ludovici collection of Roman sculpture to be seen in Rome is full of these expert "restorations,"and it is a bold visitor who can claim to spot them without the aid of the catalogue. One of the most expert of these craftsmen was Algardi, the assistant to Bernini. The line between faking and restoring in his case is hard to draw, and several pieces scattered in small museums and private collections throughout the world may well be entirely by him.

Curiously, Michelangelo was not so successful. His creative impulse was perhaps too strong. Nevertheless, he took up the work willingly because it paid well. A large group, called the Laocöon, had been found. It showed a father and his two young sons entangled in the coils of a serpent sent from the seas to put them to death. The father lacked an arm. Michelangelo was asked to supply one. He did so, with verve. The arm stretched out to Heaven dramatically. The group, as Michelangelo left it, can still be seen in thousands of illustrations in books. The arm gave the group a pyramidal structure that was enormously admired by critics as a supreme example of the vigor of Hellenistic art.

However, the Laocöon was a Roman copy. Other copies have been found. We now know that the father's arm was not outstretched to the skies. Michelangelo's arm has been taken away and the visitor can see it on the

wall behind the statue as it stands in the Belvedere of the Vatican Museum.

As for the affair of the Sleeping Cupid, Michelangelo had been very angry indeed. Baldassare had sold it as a genuine antique for two hundred ducats. Michelangelo vigorously protested, but not because the ducats had been earned by false pretences. The niggardly dealer had sent Michelangelo only a small part of the loot—30 ducats. Michelangelo wanted more. He did not get it, but he kept the thirty ducats. It was, after all, a very fine Cupid.

Bernini's lifetime spanned the seventeenth century. By the end of it nearly every piece of classical sculpture had been dug up, restored, and sold. As discoveries grew rarer, the prices mounted. So did the thirst for antiquities. To understand this we must look over the heads of our artists to a wider horizon. A change had come over the Western world.

The Reformation and the Counter-Reformation had fought matters out and by the opening of the eighteenth century both had settled down, so to speak, in their respective corners. The conflict had been bitter and, toward the end, excruciatingly boring—if not to dedicated men of the cloth, then certainly to men of a livelier mental disposition. So far as art and artists were concerned, the left wing of the Reformation—the Wesleyans and Puritans—had even less use for it than the Lutherans. As for the Counter-Reformation, Rome was

chockablock with masterpieces in every branch of art. Great churches continued to be built, but mainly in provincial cities. All over Europe monarchs of various sizes were running up palaces to rival Versailles, and the smaller the monarchy, the bigger the palace the king wanted. The largest palace in Italy was built in the middle of the century, but for the king of Naples, the poorest and most squalid kingdom in the peninsula. Vast areas of ceilings and walls had to be covered with frescoes and paintings, all in a hurry. One or two artists of genius survived the strain, outstandingly Giovanni Battista Tiepolo, and such men were in such demand as Bernini had been. Tiepolo's best work was not done in Italy but in German Würzburg, where the bishop's palace still astonishes. But lesser spirits wilted.

Then came a movement known as the Enlightenment. It began with the compiler of the first encyclopedia, Diderot. His very readable volumes take a hard look at the Christian religion, both Reformed and Counter-Reformed. He found much that was dubious. Voltaire found a lot more. Good Christians were deeply offended, but whether this is because of his arguments (which are sound) or his brilliant style (which can still be corrupting for the fledgling believer) is not clear. In any event, he set a fashion.

Patrons follow fashion and artists follow patrons, or starve. The Enlightenment turned away from the Christian civilization that had built Europe, but it had to find one to put in its place. An attempt was made to prove that the Chinese were much more civilized than the Christians, but since practically nobody could read a

Chinese book, however enlightened, this ended up in patrons collecting pots and drinking tea, neither of which did much good for artists.

The difficulty was solved by going right back before Christianity had triumphed. Every educated person could read Latin because it was whipped into him as a schoolboy, and some could even read Greek. Greece and Rome had been fashionable in the Renaissance, but this new wave was wider and deeper. It swept all Europe. The Greeks and Romans were held up as a model to the young in everything from a philosophy of life to how to decorate a drawing room. The clear bright light of the Mediterranean poured in to drive away superstition, cant, and obscurantism.

The essence, said the enlighteners, of classical civilization was measure and restraint. They had to use considerable restraint themselves in their propaganda—Nero, Messalina, Caligula, and Commodus were not ideal models of morality, but these were ignored by all but the most scholarly. The heroism of the Theban Band in war was emphasized, not the fact they they were all homosexual lovers. A clean-limbed, clear-eyed picture of the classical past was drawn up, and artists followed suit.

A great fillip to this neoclassical movement was given by the unearthing, in part, of the city of Pompeii, buried under ashes from an eruption of nearby Vesuvius in A.D. 79. The first excavations began in midcentury, but before that a treasure trove of statues had been found in Herculaneum, buried in the same eruption. But digging in Herculaneum was difficult and discour-

aging; the town had been overwhelmed by mud that had set as solid as rock. The ashes of Pompeii proved easier. The discoveries caused tremendous excitement, and Greece and Rome became more fashionable than ever. The prices of antique sculptures soared. Pompeii and Herculaneum were both provincial cities and, although bronzes and marbles turned up under the spade, there was not enough from the small towns to satisfy the demand. So the price went up still further. But, mysteriously, the supply increased. You had, of course, to be in the know. Those rascally Neapolitans who were excavating were not going to tell their employers of everything they discovered. Nor would their employers—erudite scholars as they were—be always at the dig; even scholars must sleep. So ran the word among the rich.

These rich were, somewhat to the surprise of the French, the Germans, the Dutch, and other "continentals," newly rich and—British. In the eighteenth century England prospered. All over the land, country houses, some as big as palaces, were being run up. These, known to tourists today as "stately homes," were, at first, great empty barns of houses through which the cold northern winds whistled cruelly. They were uninhabitable until properly filled up with furniture and art. Exactly the same thing happened when, in our days, huge office buildings were being built everywhere. The blank walls called for pictures. Pictures were forthcoming and bought by decorators by the size rather than content. (One of my greatest surprises on visiting the Pentagon was to find it included several corridors and offices full

of Art.) It was the same with the newly built stately homes of the newly rich England. Busts of Roman emperors, statues of pagan gods and goddesses, satyrs, nymphs, fawns, cupids, and (this being England) even classical dogs were everywhere, right out into the land-scaped gardens.

Where did all this sculpture come from?

Joseph Nollekens (1737–1823) was the son of a painter from Antwerp. He was born in England because his father had emigrated there to paint pictures to cover the walls of the stately homes that newly made earls, barons, and knights were running up apace. Joseph took up sculpture and quickly won three prizes from the Society of Arts, an organization that was a novelty for Britain, but a necessary one. There were no art schools: the Royal Academy did not yet exist. The Society of Arts was a body of gentlemen amateurs who had houses to fill and wanted some sort of employment agency to get the people (mostly immigrants) to do it.

Pocketing his three prizes and shrewdly estimating the tastes and needs of the time, Joseph went off to Rome. This city was the principal stop on the Grand Tour, an educational trip which the sons of the new British aristocracy were expected to take in order to improve their taste and manners. Manners in England at the time were not very polished. Drinking was heavy. But the son of the house, on his return from the Grand Tour, could be expected to slide under the table with

grace and perhaps a Latin tag on his lips, while busts of
Roman worthies and gods stared down at him from
pedestals as the footmen carried him off to bed. These
busts and statues he was expected to buy in Rome.

Nollekens soon made friends with another English-
man, a dealer in antiques called Thomas Martin. The
latter introduced him to a gang of Italian sculptors who
were all busily faking Roman and Greek statues to sell to
the English milords. Nollekens joined the gang with
enthusiasm. As his cover he set up as a restorer and even
did some original works of his own to leave around the
studio. The young men on the Grand Tour would
inquire if there were any genuine antique sculptures to
be bought. Nollekens and his colleague would instantly
warn him of the rascally Italians who were turning out
fakes and gulling innocent Englishmen into buying
them. The young visitor, already warned that Italians, in
addition to being Catholics, were thieves to a man,
would be grateful for such good advice, especially since
it came from a co-national and in his own language.

The next stage of the con, as we would say, was to
impress upon the mark that any genuine find was
instantly snapped up by Italian collectors. Since the
young man had already spent long evenings in Italian
palaces crammed with statues, he could well believe it.
However, he would be told, the Italian collector was
stingy. It was well known that English milords were rich,
very rich. There were pieces from Herculaneum, or
Hadrian's villa, or the Baths of Caracalla, that, no sooner
than they had seen the light of day, were hidden again.

Milord, intrigued, would write home to his father

and, after the customary abuse of the pope and his superstitious ceremonial, would drop a hint about the sculpture. Father, busy adding a new wing, would urge him to buy.

Nollekens would take the mark to some cottage in the countryside where, under straw and sacking, would be one of his fakes. The Grand Tourist would pay over his golden sovereigns and Nollekens would promise to smuggle the statue out of the country.

It is a matter of astonishment that this technique still works, even today. The marks are Americans or Venezuelans or Argentinians (Arabs as yet are not collectors). The fake is nowadays Etruscan. Two magnificent fakes of this sort were for a long time the pride and joy of the Metropolitan Museum in New York.

The stately homes of Britain are no longer so full of fakes as they used to be in, for instance, the Victorian age. Taxes and death duties have stripped most of them of their major works of art, as is well known. But a fake needs no export license and is thus easier to sell. Yet many still remain, jealously preserved and cared for, often under ambiguous labels, by the worthy National Trust.

The best-known fake is that at Petworth, a stately home much-visited today. The showpiece is a head: "the Praxiteles head," as the tour brochures and guides say. The label is a little more honest. It puts Praxiteles into

inverted commas. The head, for all it is worth, could be put in the cellar to nobody's loss. Only two carvings by Praxiteles are known, and there is much dispute even about them. Neither is in Britain. There is no doubt that the buyer of the "Praxiteles" went to his grave thinking he had bought a priceless classic. It is a Roman eighteenth-century fake, and not a very good one.

There is another fake with a much more romantic history, again a head, this time attributed to Phidias. It was bought by Axel Munthe for his villa, San Michele, and it is to be seen there. Thousands stare at it every spring and summer, because Axel Munthe wrote a gossipy best seller about the villa and the guests he entertained there. By its long-dead owner's instructions, it is covered by a velvet cloth. This is reverently withdrawn by tour guides a dozen or two times a day, thus echoing the gesture of Munthe when he showed off his treasures. He always claimed that the head had been dredged up from the offshore sea bed. It is plainly false, but rather better than the one in Petworth. I was very fortunate in being able to discuss it with Edmondo Cerio, Munthe's friend and so prominent a dweller on the island that he was known as the King of Capri. He had a fund of amusing stories about Munthe. I mentioned the famous head. I doubted that it had been dredged up from anywhere but the Via Babuino, for a century and more the street in Rome that does a brisk trade in works of art, mostly bogus. "Naturally," said the King of Capri, "that is exactly where my dear friend Axel bought it."

The most beautiful of the specimens that came

from the chisels of the Roman fakers is to be seen in Rome itself in a place of honor in one of Rome's principal museums, that of the Palazzo Venezia. It is not classical. It is a rather late fake, and British tastes had veered back to the Gothic. This is a very lovely head of an unknown pope, gently inclined, with a melting glance. It has no label. The catalogue is honest but expensive to buy. The fake has countless admirers every year, which would surely please, or at least amuse, the faker.

What sort of men were these manufacturers of antiquities? One would imagine they were modest men, uncertain of their gifts, and glad of obscurity and the money. Nollekens, at least, was not that at all.

Having lined his pocket amply, he returned to England. He offered himself to the nobility not only as a restorer but as an original artist. He had timed his move well. The importation of foreigners had very mixed results. The immigrants were often artists who had been chased out of Italian studios with kicks for being so bad. The grand staircase at Petworth is lined with enormous frescoes done by an Italian, so clumsy that one wonders at the taste of the people who went up and down the steps.

Not all of the nobility were ignorant of art. Lord Burlington was an architect in his own right and a collector of considerable discrimination. During Nolleken's absence in Rome (which lasted a decade) the

Royal Academy had been founded, and it is now housed in one of Lord Burlington's palaces. It seems that not only were some Italian artists kicked out of Italy and told to go to England where nobody would notice how bad they were, some were kicked out of England and told to go back to Italy.

This happened to Giovanni Battista Guelfi (d. 1734). Lord Burlington had brought him to England at personal expense. According to the records, in 1734 Lord Burlington returned him to his native land with thanks. His dull, lifeless work that remains suggests the reason. He was also, says his contemporary biographer, "slow of speech, much opinionated, and as an Italian thought nobody could be equal to himself in skill in this Country. Yet all his works seem to the judicious very often defective, wanting spirit and grace. It's thought that Ld. Burlington parted with him very willingly."

Nollekens seized his opportunity with both hands. To be anybody you had to come from Rome. Not all Italians were good. Nollekens *did* come from Rome, in a sense, and he was very good indeed. The fashion was to have a bust done of oneself looking as much like a Roman senator as possible. John Bull's nose was rarely aquiline or his brow lofty. Romans did not hunt foxes in bitter weather and Nolleken's sitters were often as badly battered as the antique busts he had lived with for a decade in Rome, but he did wonders. If he did not turn the British nobility completely into Romans, he made them look like every schoolboy's headmaster in a temper, and that did just as well. The money was good for busts, as I shall show in the next chapter.

Nollekens prospered. He was made an associate of the new Royal Academy in 1771 and a full member of that body the next year. He was, in a word, respectable.

Or nearly so. We have seen that the Enlightenment had to tread carefully about certain aspects of classical civilization. Socrates could be ranked next to Jesus in controversy but it was as well to omit all marked references to that dialogue in which he confesses to looking up a small boy's tunic and growing very interested. The *Symposium,* too, could be called sublime, but all the talk about Love was about pederasty. Was it a Good Thing, or Bad?

Well, it sold sculpture to the Enlightened ones. Naked young men and male adolescents turned up under the spade and were snapped up by collectors. Fakes along the same ambiguous lines were also welcomed. Copies of the more famous originals were eagerly bought, even if they had to be tucked away behind shrubbery in the grounds.

One such copy shows us what an extraordinarily good sculptor Nollekens could be when he was being honest. There existed a classical sculpture showing the Roman gods Castor and Pollux, or perhaps just two adolescents. They are as naked as worms. They have the faces of angels, and one has his arm affectionately around the shoulders of the other.

The original, restored, was bought by Queen Christina, she of the breeches (it is now in the Prado in Madrid). Nollekens copied it and did so quite honestly: that is to say, he did not pass it off as genuine, and, in any case, the whole world knew Christina had the original,

since she took care the whole world knew everything she did.

Nolleken's copy is an exquisite piece of chisel-work. It shows why his reputation stood so high among contemporary patrons. Nollekens knew that, in a left-handed way, he was the genuine thing. He had spent ten long years in the Eternal City, studying the antique, and one never studies a thing more closely than when one is making a fake of it. This knowledge gave him pride, even arrogance. A rather feeble but popular sculptor called Flaxman had made disparaging remarks about him. Here is Nollekens thundering in reply:

> I don't like him . . . he's always talking about the simple line in the antique. Why, he has never been to Rome: he has never been over the Alps: he has never been at the top of Mount Vesuvius while I have washed my hand in the clouds: what can he know about the matter?

It is all true: Flaxman's line was simple to the point of being of ladylike insipidity. He had never gone to Rome. He had never faked a statue and sold it to a noble Briton. Nor could he turn out anything so perfectly adapted to a limited, but paying, market as Nollekens' copy of the two boy lovers. Today it is in London, in the Victoria and Albert Museum. It is a masterpiece. I hope neither Victoria nor Albert ever saw it.

Chapter 9

The Birth
of the Grant

The English grew even more prosperous. Their trade increased so fast they even had that accolade of a booming nation of businessmen, a financial crash which ruined a lot of them. The South Sea Bubble, as it was called, was a wild gamble in stocks and shares over the prospects of trade in exotic places such as South America. It was not as bad as the Wall Street crash of 1929, but, like that, it jolted the nation. It caused England to put its affairs into the hands of a politician instead of leaving them to monarchs. Sir Robert Walpole, the first prime minister, understood money so well he ran the most corrupt administration in British history. But

abroad he kept the peace as long as he could, and peace was good for trade. Britain was set on the path that led her in due course to own three quarters of the earth.

A Frenchman of outstanding abilities in several fields thoroughly despised this money-grubbing, an attitude many people today, especially those with cultivated aesthetic sensibilities, readily share. The Frenchman was Napoleon Bonaparte and he called the English "a nation of shopkeepers." After a considerable to-do and much expenditure in gunpowder, the English put him on the island of St. Helena, where there were very few shops of any consequence to disturb his peace of mind in retirement. In the course of this operation, the English produced such heroes as Horatio Nelson, but he, too, never lost sight of the importance of money. On being knighted, he point-blank refused to pay for his sword of honor.

Artists did well financially, as they usually do in a rising economy, Whether they did as well artistically is a matter of debate. The great fight to put the French in their place had thrown up a covey of admirals and generals and commanders-in-chief, whose tombs had to be weighed down with the fashionable sculptures. A walk around Westminster Abbey will convince most people that the monarchs of England are crowned in the midst of the biggest collection of kitsch in the world.

But every art student today owes homage to one of the sculptors and to the English sense of the importance of money. Sir Francis Legatt Chantrey, R.A. (1781–1841), invented the grant in aid—and out of his own pocket.

In the Royal Academy of Arts is a *tondo* (a circular plaque) of the Madonna and Child by Michelangelo. It is visited and admired by every artist who can manage to do so. But the Academicians have another possession they do not show to the public. It is Chantrey's ledger, carefully kept all his life with the meticulousness of any tradesman. It is a relic that should be reverenced. He set rolling a ball without which thousands of artists of all colors and countries would have fallen in despair by the wayside.

Chantrey's rise to fame and fortune is dramatic, but a more undramatic artist it is hard to imagine. He matches President Calvin Coolidge for the brevity of his comments and may be said to have surpassed him. When, at the height of his fame, he was taken around the endless galleries of the Vatican, he said nothing at all.

He was born (April 7, 1781) in the country near Sheffield and was very poor. His father was a carpenter but died when Chantrey was twelve. Little Chantrey was left to get along as best he could and for a time worked as an errand boy for a grocer. Idling on a task as errand boys do, he would loiter outside the shopwindow of a woodcarver, Robert Ramsay, who also dealt in prints and pictures. These, and some plaster casts of busts, took the errand boy's fancy. He changed jobs and got himself apprenticed to Ramsay in the humble capacity of a cleaner of pictures. The bond (to be paid if he broke the term of his apprenticeship) was fifty pounds. Chantrey began to draw and paint.

The usual story at this point is that good man Ramsay saw the boy's talent and encouraged him to go on. This, however, was commercial Britain, not Renaissance Italy. Ramsay grew violently jealous and there was constant quarreling. In Ramsay's defense it should be said that Chantrey was something of a lout. He had learned reading, writing, and arithmetic at the village school, and nothing else. This lack of education bothered him all his life. He was no Rubens or Bernini, and regretted it.

Repulsed, Chantrey hired a room near the shop for a few pence from his meager salary and got down to work. He studied to be a portrait painter. His success at this soon won him friends. They made a collection of money and bought him out of his apprenticeship, paying Ramsay his pound of flesh, that is, £50.

Here we must tackle a difficulty. There is no point at all in trying to convert the pound sterling of those days into modern currency. A person, in the famous phrase, could "be passing rich on forty pounds a year"; on the other hand a landed proprietor could have an income of thirty thousand pounds and not consider himself over-rich. There is a measure, on the other hand, for anyone concerned in the arts. Institutions give prizes. These are rarely very large, but are not too small to be treated with contempt. The Society of Arts also gave prizes, and here are the sums as won by another British sculptor, Thomas Banks:

In the year 1763 for a low relief in Portland stone: £31
In the year 1765 for another, this time in marble: £26

In the year 1766 for another of the same: £10
In the year 1769 for a model in clay: £21
In the year 1769 for a design for ornamental furniture:
£21

The artist was clearly a popular young man, for his first prize was won when he was only twenty-eight. The average works out at around twenty pounds. Twenty golden sovereigns then could make a young artist happy and proud and also pay for his materials and time.

We can now study the accounts of Chantrey. He gained recognition even earlier than Banks. He studied at the Royal Academy when he was twenty-one and two years later exhibited a painting. However, marble busts were all the fashion, so he spent a year mastering the technique. He married a woman with a certain amount of money, which helped to launch him properly. By the time he was twenty-seven he could ask, and get, says the account book, one hundred pounds for his bust of a Dr. John Brown—rather like winning five prizes at one go.

From then on, he does not look back. In 1813 his price advanced from £100 to £150 for a bust. One shilling (the twentieth of a sovereign) per pound sterling should be added to these figures, for an artist was now being paid like a gentleman in a thing called guineas, a gold coin worth slightly more than a pound. Lawyers and doctors were paid in guineas (and so were bets on horses) to show that they were not mere workmen. Guineas ceased to be minted (1817) almost as soon as Chantrey began putting them in his purse, but right up until the end of World War II a specialist doctor and a

surgeon and a fashionable portrait painter would still send in his bill in guineas and leave the patient or the sitter to work it out in real money.

Chantrey now solidified his reputation by two financially valuable things. By the time he was thirty-seven he became a full member of the Royal Academy. This was a most important step, so far as prices were concerned. By 1822 he upped his price from 150 guineas to 200 guineas for a bust. Napoleon, who had jeered at the British, had been dead a year. Nobody, for quite a while, made any busts of him, but in triumphant England to have your friends comment on your solid marble head was not an insult; it meant that socially you had arrived.

So had Chantrey. The king was George IV, and he asked Chantrey to make a bust of him. Chantrey did so. He presented it to His Majesty, who inquired the price (like a good monarch of a nation of shopkeepers) and was told it was 300 guineas, including the price of the marble. George IV was a remarkably unattractive man. He was heavy-jowled and grossly fat. Chantrey's portrait is an idealized version of his monarch It had to be: a realistic bust might have landed him in the Tower of London. The king did the handsome thing. He paid Chantrey his 300 guineas, and fifty guineas extra.

Royal munificence was nothing compared to that of his subjects in the distant parts of the nascent British Empire. In faraway Calcutta Bishop Heber was baptizing Hindus and doing his best to restrain the greed of his white congregation, which had money coming out of its ears. When he died, Chantrey was asked to make a monument for Heber, which he did. The good bishop is

on his knees, whether in private devotion or asking God's forgiveness for the sins of the East India Company is not clear. This cost the diocese no less than £2000. Not only that, but there was so much money around that a copy was commissioned for that cathedral of the financial center, St. Paul's.

How were these prices fixed? In 1776 a Scotsman, Adam Smith, had published a book, *The Wealth of Nations,* explaining how the price of everything, from bacon to bishops in marble, should be arrived at. It was supply and demand operating in the free exchange of the market. This was what the British (and the Scots) were doing and, according to Smith, it was an arrangement that could not, and should not, be bettered. Economists in Europe and America still get red in the face defending Smith or abusing him.

Without entering into that dispute, we may say that in such marginal matters as the price of a bust the free play of supply and demand needed a little encouraging push or two. This came from the Royal Academy. Modeled on similar institutions on the Continent, the Royal Academy chose among the swarms of artists certain ones whose work pleased the top members. These were first associates; then, if they continued to paint or sculpt well, they were made full Academicians. Also, if they gave up painting or sculpting and took to drink, the Royal Academy was understanding, and made them RAs all the same. These two initials sent up the price of an artist's past or present work considerably. It is inclined to send it down today, but we live in more unsettled times than those of Adam Smith.

Perhaps that gave artists time to think—not only about their art, which they must do come hell or high water, revolutions or wars or worse, but also about the sinews of artistic creation, which, like war, are money. An artist who is poor (and Chantrey had been as poor as could be) must find money somewhere or be a fakir and learn how not to eat for extended periods. Alternately, he can marry money (as Chantrey did in a modest way). But to marry money is often to invite trouble into one's studio accompanied by a troupe of offspring. Cyril Connolly, the literary critic, has remarked that the biggest enemy to promise is the perambulator in the hallway.

Chantrey died comfortably off. He had made his will on December 31, 1840, one year before he died at the age of sixty. The first bequests are, I think, moving. Fifty pounds a year is to go to educate poor boys of Norton, the parish in which he was born. Not a vast sum, but teachers are always poorly paid; at least some of the boys of Norton would not go through life, meeting the great right up to the king, and feeling always a lack of learning as Chantrey had.

One hundred pounds a year is to go to the vicar of Norton "as long as my tomb will last." The stately homes of England are now, in most cases, maintained by an organization called the National Trust. Here we have an embryo National Trust set up with considerable ingenuity. If some restorer in future ages should say "Let's take away that tomb of who-the-hell-is-it and put in a stained

glass window in memory of the Duchess," the vicar loses one hundred pounds a year. Clever, and curiously modest.

Next he provides for his wife. Nothing shall be done with the rest of the money "until the first day of January in the year succeeding that in which my said wife shall die or marry, as the case may be." He had used her dowry to climb the ladder; she would take none of his money to a second husband. Farseeing: did he know that his wife, once he was in that tomb, would fling herself, thanking God, into the arms of a man who never touched a chisel or a paintbrush in his life? It happens.

His wife out of the way, he comes down to what is really in his mind. The Royal Academy was the one institution that could bring some taste and order into the art world of fast-expanding Britain. The president was necessarily a practicing artist and, in the way of things, probably in decline. It is an honor not likely to go to a young man. The president, then, is to receive an annuity of £300 "for his own absolute use and benefit." One man, at least, in all prosperous Britain, need not go hat in hand and bottom on chairs in antechambers, seeking commissions from wool merchants, plethoric noblemen, or even the royal family. Nor need he flatter the sprigs of those same classes who dabbled in painting. He had his independence (if, of course, he did not squander the money on wine, women, and the horses; but who can draw up a will to prevent that?).

The next provision is mysterious. The secretary of the Royal Academy is to get an annuity of fifty pounds a year "on condition that such secretary shall attend the

meetings of my trustees and keep in a book to be preserved by them a regular account of the proceedings." The words I have quoted are underlined in the original document by Chantrey himself. Did he not trust the trustees? Would fifty pounds a year make the secretary an honest reporter? We do not know.

Next comes the essential clause, the one for which, in our own time, Chantrey's name is remembered. "The clear residue of the same monies shall be laid out by the President and other members composing such Council, for the time being, of the Royal Academy or of such other society or association" (perhaps there would be no "Royal" Academy; the French had chopped off the head of their king when Chantrey was a little boy in Norton) "when and as they shall think it expedient in the purchase of works of Fine Art of the Highest Merit in Painting and Sculpture that can be obtained."

The grant in aid had begun, and it continues. Once and for all, an artist was no longer dependent on the taste of patrons and their wives. He could make his name by the judgment of his fellow artists. In the subsequent history of the buying the Academy has often acquired work by artists who, though plainly talented, had not made the commercial market. In the doldrums of British art that struck the country in the first decades of the twentieth century, Chantrey's bequest, handled mostly with discernment, kept alive the idea that the British artist did exist in his own right, independently of daubing portraits of royalty and minor royalty and even minor celebrities. Not all of the Chantrey buys were good but it would be invidious to say which, and

certainly disputable. Yet Chantrey had spent his money in the right way. It has been followed by countless benefactors endowing universities or museums or art schools. Mr. Moneybags steps down and leaves the judging to those who should know.

But did they? We now enter upon a quarrel which in the small world of art was as vital and bitter as that between Protestants and Catholics. At the moment the rebels are winning. We may be on the eve of a Counter-Reformation. Here, in the meantime, is the story of the struggle.

A great change was coming over the art market, and it is strange to reflect how men of creative genius are affected by circumstances over which they have no control and often do not even understand. How many unsung Michelangelos and Raphaels were destroyed by the neoclassical movement we cannot know, but we can guess.

The people responsible for it are as bizarre a collection as one could hope to find: a closet homosexual; the most notorious (and contented) cuckold of the century; a gaggle of archeologists on the make who did irreparable damage; and a beautiful woman whose name was Marie Josèphe Rose Tascher de la Pagerie. Marie-Rose changed her name to Josephine, but in the end it did not do her much good. All the same, she put millions into the pockets of artists.

Johann Joachim Winckelmann was a lover of young male beauty, both mineral and animal. He adored, that is, Greek statues and handsome Venetians. He kept quiet about the latter, but with the former he produced a revolution in artistic taste. He studied the discoveries being made in Italy and wrote a book called *The History of the Art of Antiquity*. It is a very good book. It is a panegyric largely concerned with the merits of the nude statues that had attracted (as we have seen) the Renaissance and Bernini. From these he argued that the only true taste in art was the antique Greek. He roused all the more refined spirits of Europe to a passionate love for Greek sculpture. Unfortunately, in a long and active life, he never saw any. The statues he saw were all Roman copies, often very slapdash ones. Another mistake he made was to go into a dark alley in 1768 with a Venetian, who bashed him on the head and killed him.

Before that happened he had visited Pompeii. What he saw shocked him. Excavations were going on at a fever pace. Houses were being dug up, frescoes hacked out of the walls, statues carted off and both sold to any buyer. Homes that had been ransacked were filled with earth dug out of the next house, to remain hidden down to our own times. He protested. The King of Naples was making a collection of his own and encouraged the vandalism. In any case, the discoveries were a sounder investment than the taxes he screwed out of his rebellious subjects. He kicked Winckelmann out of his kingdom.

At the same time there was an English ambassador

at the king's court who was a man of taste and discernment with a devouring passion for antiquities, Sir William Hamilton. He liked pretty women, too, but in a much more tranquil fashion. While making a vast collection of Greek vases, he found time to fall mildly in love with a high-class prostitute called Emma Lyon, the daughter of a Cheshire blacksmith who might have been called Lyon, but then again might have been called Hart. Lady Hamilton did not particularly like Art but she liked sailors, particularly Nelson, who had cast anchor in Naples harbor. He carried Emma off with no great objections from Sir William, who was thus given the leisure to pursue his real interests.

Hamilton invited Winckelmann to come back to Naples, and under his protection Winckelmann once more visited Pompeii. His report did a great deal to produce some order and less downright thievery in the excavations. The discoveries did a great deal to support Winckelmann's now-famous enthusiasm for Greek art, though not a single statue or fresco was, in fact, Greek.

We now pass to Marie-Rose. She had come a long way from her Caribbean birthplace, Martinique. She had married Napoleon Bonaparte, and he had become Emperor of the French. Neither Napoleon nor his archrival Nelson had much luck with their women. Nelson returned to England to have mobs under his window shouting ripe insults about his whore, while Napoleon divorced Josephine.

But before that catastrophe hit her, Marie-Rose showed she had good taste in art, if not in husbands. An elegant woman, she adopted the hairstyles and frocks of

the women of the frescoes in Pompeii. Thanks to Winckelmann, more care was now being taken by the excavators, and thousands of household objects and even furniture were being discovered and illustrated in books of engravings that were eagerly bought by everybody who wanted to be in the fashion.

Napoleon, too, had need of a style. He followed Josephine's tastes, and the "First Empire" period in furniture and decoration was born. Neoclassicism, as the movement was called, had come to the very top.

A young man from Treviso in Italy called Antonio Canova had drawn attention to himself by his work, including (if it is not a legend) a lion done in butter. Canova (1757–1822) came to Rome, where he soon found a patron. This man knew about art and money, and he told Canova flatly that if he wanted to make any of the latter, he had better follow Winckelmann and be a neoclassicist.

Winckelmann's favorite statues were all smooth and white, since the Roman copyists had dropped the subtleties of the Greek originals in order to mass-produce for the market. Canova duly made smooth white statues which, since his marble was fresh from the quarries at Carrara, were as cold as icicles. They were enormously admired and Canova prospered.

There are two examples of the effect of the art market on a talented man, both in a way comic—or sad, according to the way you feel about such things. Canova's natural style was free, rich, and, above all, warm. His early self-portrait, with which he won election to the Academy of St. Luke (in Rome), shows this. In

contrast, he did a statue of Napoleon in the year of that man's triumph. It is of colossal size. The neoclassicists had explained the fact that so many of the "Greek" statues were naked because something called "heroic nudity" was the Greek tribute to great courage. So the victor of Marengo and Austerlitz is shown without a stitch on him. The statue is now in Apsley House in London, the residence given by a grateful nation to his conqueror, Wellington. It is so big that it had to be put in the well of the grand staircase. Guests mounting this could examine the bare Napoleon inch by inch. His genitals are classically heroic in size—that is, unnaturally small, a rule among the Greeks and Romans that the neoclassicists had followed faithfully.

Among monarchs in exile in Rome besides Queen Christina are to be counted the Stuarts, once the ruling family of Britain. They too were Catholics and equally far from welcome. ("Yes, but why *here*?" asked the reigning pope when he heard one of them was coming.) All the same, they have a monument in St. Peter's, small but elegant. Canova provided two high reliefs of angels, life-size, in the shape of two adolescent boys, very classical and much like the two that Queen Christina bought and Nollekens copied. Their shapely bottoms are at a height that can be reached by any visitor who cares to stretch out his hand. The marble is white except for these buttocks, which are stained brown from the innumerable pats that have been given them by millions of pilgrims in a happy mood after being shrived of their sins at the tomb of the Apostle.

To his great credit, at the height of his fame Canova

became aware of the betrayal of his talent into which an art critic, Winckelmann, and the art market had led him. The Englishman Lord Elgin, by judicious bribery, had managed to get the remaining marbles of the Parthenon lowered to the ground and transported to England. His aim was, of course, to sell them. He began the process of dipping deep into the public purse for the sake of culture and uplift that flourishes today. The British were at first enraged, members of Parliament protesting at being asked to buy what they called a "collection of old stones." But this philistinism was dampened down and the statues were sold for £35,000. It was a lot of money for the public to shell out.

Canova visited England. He saw the marbles. He wrote back a highly indignant letter to Rome. Everybody had been deceiving him, critics and patrons alike. These, the first genuinely Greek marbles he had seen (or most other people, for that matter), were not cold at all. The "flesh" was astonishingly warm.

The art critics and the dealers, after an interval, came up with an explanation, as they always do. The warmth was due to the particular marble used and its aging under the weather. The embarrassment subsided. Statues continued to look like icicles for some time.

The explanation was not correct, though in fairness it should be said neither critics nor dealers could have known. Since those days, unfinished statues have been found in Greece, including one still on the site of the quarry from which it was being hewed. The Greek sculptors attacked the marble with a drill. The surface thus "softened" was scraped with a chisel in the shape of

an iron claw. Only then did the normal chisel come into play, and then lightly. Finally, the statue was rubbed down with sand and oil, but so as to leave the minute irregularities of the surface still there, to catch and play with the light. The Roman copyists, as we have noted, had no time for lengthy procedures—hence the coldness of their copies.

By the munificence of a modern art dealer, the Elgin marbles can be seen in the British Museum illuminated by an artificial light closely resembling the sunlight of Greece, or as near as can be had. The visitor can now study the technique of the drill, and it is best done in the statue of a horse's head.

The same visitor, while at his studies, might care to remember that the splendid galleries and its lighting were the gift of Joseph D. Duveen, later Sir Joseph, later still, *Lord* Duveen of Millbank, after attaining which dizzy heights he went satisfied to his grave (1939), followed regrettably by the reputation of having mercilessly rigged the art market and so made his fortune. (That is another technique we shall examine.)

The artist bound by the rules of a medieval guild was a long way in the past. He was now free, honored—and paid. Yet the guilds managed to come in again, by the back door. Their place was taken by the academies. True, there were no longer rough guild masters, proud of their workman's garb and toil-hardened hands. The Academics were all thorough gentlemen, at least from

the time they became academicians. They may, like Chantrey, have had humble beginnings. But when the honor of election was conferred on them, they were welcome in the best society. The bonds that bound them now were silken.

As the nineteenth century rolled on, everybody who aimed to be thought educated strove to have Good Taste. Good Taste was the avoidance of Vulgarity, a crevasse into which it was only too easy to fall in a European civilization running on steam engines and unbridled commerce. It could be acquired. Authors earned good money teaching it. John Ruskin wrote a great deal of beautiful prose about it. He was the most utterly nonvulgar man of his times. He never did or said a coarse thing. He did not even go to bed with his wife. Prince Albert, the husband of Queen Victoria, strove mightily to teach her subjects Good Taste in all the arts. His life on this earth was a long series of disappointments in the matter, and when he looks down from Heaven at the Albert Memorial, life there cannot be unalloyed bliss. Still, he did his best.

There were pitfalls in Good Taste as well as Vulgarity. The Academics busily filled them in and smoothed the way for the newly rich all over the continent of Europe. The French Academy even set up headquarters in Rome and gave promising young artists bursaries— monetary grants—to go and live there to be sure they came back soaked in Good Taste—which was, of course, classical. The Prix de Rome became one of the best starts for an artist's career.

Jacques Louis David (1748–1825) won it in 1774.

He was so perfectly in tune with his times that, in the French Revolution, he nearly had his head cut off, the guillotine being very much in fashion. Surviving, he greeted Napoleon's Empire with enthusiasm. He painted industriously, making all the celebrities look as Roman as possible. Some look like waxworks, but his portraits of Napoleon do convey a living and impressive likeness. David had drawn the heads of actual contemporary Romans, posing for artists being one of their critics' lucrative professions. There was, and is, not a single descendant of the classical Romans in Rome; it was taken over in the Middle Ages by Corsicans. Napoleon was a Corsican, which may be why he liked David's pictures so much. Apart from his big imperial set-pieces, David painted a picture of a woman that is immortal. It is of Madame Récamier, a society hostess. She reclines on a Pompeian couch and is dressed in the complete Pompeian style.

What else? The Academics now completely dominated the art world, and did so until near the end of the century. To make a living an artist had to be hung in the Salon if he were French, or the Royal Academy show if he were English. Neoclassicism waned in France but survived in Victorian England. Sir Lawrence Alma-Tadema painted enormously popular (and very expensive) paintings of Roman ladies in Pompeian settings, not heroically nude but very briefly clad. I shall not go into the merits or demerits of academic painting. The subject is too risky. When I was younger, auctioneers would knock down an Alma-Tadema for the first bid of

fifty pounds. They now tell me that his pictures are fetching very big prices. The oil sheiks like them.

What will concern us now is the reaction against neoclassicism and the way it gave rise to another way of making money from paint and canvas.

Chapter 10

The Truth about a Famous War

The war was between the Academicians of France and a group of painters whose names resound in the history of art. The truth about it is that the artists won the war, but by the somewhat unsoldierly tactics of going over to the enemy at the right moment. Nothing can detract from the glory of such painters as Monet, Renoir, Manet, and Cézanne, not even this chapter. But I think it is interesting to know what really happened, now that the smoke of battle has cleared.

The story has been told many times in studies, novels, films, and—whenever that medium thinks it time to raise its sights for an off-peak period—on television.

But for me it was put very neatly by two very handsome young Italians. I eavesdropped on them in the National Gallery in London. They were obviously on their honeymoon, obvious that is to anybody who knows the Italians. It is a ritual that after marriage the groom takes the bride on a trip. It will include visits to museums, galleries, and churches. Nobody knows why. The bride is usually bored to distraction. They may never set foot in a picture gallery for the rest of their lives. Yet they do it; perhaps to get it all out of the way and set about having a lot of children, perhaps to keep up appearances in later life when interfering foreigners talk about saving Venice, and such. They have been there.

I came across them in front of a painting by Cézanne, *The Bathers.* He was telling her, in Italian, of the Impressionists. He was good at it; he was even passionate. I had the feeling that it was his last chance to talk of such things before he would be rudely interrupted and told to go and warm the baby's milk.

He told her how a group of artists led by Monet decided that the Academicians were not using their eyes. He told how once, when a painting of a cow and a cowherd was called for, someone was sent out to bring a cow and its owner into the painter's studio. The Impressionists—though he warned her in a learned aside that they did not like the name—went out into the countryside, set up their easels, and painted what they actually saw.

The Academicians were scandalized. They refused to hang their pictures in the Salon, which meant nobody would buy them. Thus these artists starved, but still they

went on painting. The public called them rude names and once, when they held an exhibition, the police had to be called in to stop a riot.

"And yet," said the bridegroom with a magnificent gesture toward the Cézanne, "the British public have just bought this for one million pounds!"

"They *have?*" said his bride.

"Yes." He pointed toward a box marked THE NATIONAL ART COLLECTIONS FUND in which she could actually see pound notes tucked inside.

His bride looked around her at the other visitors. "And they strike you, don't they, as such *sensible* people?" she said musingly.

"Why?" said her new husband. "Don't you like the picture?"

"No," she said decisively. "Who was it you said did it?"

"Cézanne."

"He can't draw. My brother Tonino can draw better than that, and he's only fourteen."

The young man rolled his eyes despairingly.

"He wants to be an artist," she went on, "but Father won't hear of it."

"Why?"

"Because, like you said, there's no money in it. Well, you did say that, didn't you? About starving?" She took his arm and moved him on.

I came across them again some fifteen minutes later. They were in front of a famous canvas of Ingres. It is of a middle-aged woman, obviously rich, splendidly clothed and painted in meticulous detail.

"Now *that*," the bride was saying, "is what I call a good picture. Who did it?"

"Ingres," said the young man gloomily. Then with some irritation he added, "Can't you read the label?"

"Ingress," she said, doing so and saying the name in the Italian way. "We must buy a post card and send it home. Remember—Ingress. Tonino will love it. He did a drawing of Mamma that was ever so like this, and . . ."

"Must we go on talking about Tonino?" said the bridegroom.

There was a little silence between them.

Then she said placidly, "Tonino doesn't like you either. But you'll get used to each other." She took his arm again and they disappeared into the next gallery.

So far from being the starving artist trying to earn a crust of bread by painting revolutionary masterpieces that a stupid world would not buy, Paul Cézanne (1839–1906) was precisely like his honest self-portrait to be seen in London's Tate Gallery—a thoroughly well-fed, even jowly, French provincial.

He was the son of a successful banker of Aix-en-Provence, Paul-Auguste Cézanne. Paul-Auguste was the sort of father (despite the legend) that many young artists reading these lines might devoutly wish he had. He gave his son a private income all his life and finally left him his money. This in spite of the fact that Paul was a disappointing offspring. His father, naturally enough, wanted him to go into the bank and since he could not

study economics (the happy breed of men had, as yet, no professors to teach the subject) Paul-Auguste suggested that his son study law. But Paul wanted to be an artist.

There was only one place where art could be learned properly, the École des Beaux Arts (the School of Fine Arts) in Paris. So Papa, footing the bill, sent him there. The school was dominated by Ingres, who, as our Italian bride noticed, could draw exceedingly well. Cézanne could not, at least according to his fellow students, who howled with laughter at his efforts. But Papa continued to pay Paul's allowance.

It was not much, but it was sufficient for a single man to have food, lodging, and clothes, together with paints and canvas, and still have money in his pocket to stand a round of *bocks* to his friends at the Café Guerbois. They were a lively lot, being a group of artists who, having been rejected by the committee that chose the pictures for the annual Salon, decided to defy what we would nowadays call the Establishment. This group called itself The Independents. They all agreed to hang together and not send in their pictures to the Salon. This meant that it was unlikely that anybody would give them money for what the Selection Committee for the Salon called their hasty, unfinished, ill-drawn daubs. Some of the Impressionists (as we know them today) were rather shaken by this bold decision. But loudest of all in supporting it was Cézanne. He, after all, had Papa behind him—who, despite the plain evidence that his son was a failure, continued to send him his allowance.

Then father and son had a quarrel. It was not about art or Paul's bad drawing. Paul kept pressing his father

to increase his allowance, saying that it was not enough to live on in Paris. This roused the banker's suspicions, because he knew that it was. He discovered that Paul was living with a mistress, Hortense Fiquet, with whom he had produced a son. Papa put his foot down. If Paul wanted to live with a kept woman, he must keep her himself.

Paul had discovered two things: that practically nobody would buy his paintings and that two cannot live as cheaply as one, to say nothing of three. Did Cézanne struggle on gallantly, painting away in the fields while Hortense pushed the hair off her forehead and sweated over a hot stove with a pan of sausages? He did not. He decided he would go back to Papa. He found it difficult to dispose of his pictures, but no difficulty in disposing of his mistress and son. He parked them on a friend and took off for Aix-en-Provence and home.

This had been done before by others without making the history books. In this case, however, the obliging friend was Émile Zola, who had just published a best-selling novel, *L'Assommoir*. Zola had been at school with Cézanne. He was a fervent supporter of the rebel artists and these two facts may account for his generosity. On the other hand, they may not tell all the story. Reading through Zola's writings on art, one gets the feeling that he really did not know very much about painting; he grew very tepid about the Impressionists when his fame and income were securely established. But, like other best-selling novelists, he knew a good deal about the art of self-promotion. He had made his name as a daring realist writing about life in the raw. The Impressionists

sat out in all weathers realistically recording the play of light. Zola's support of them (and one of their mistresses) did no harm to his public image.

Cézanne's paintings of his native Provence now hang in every major gallery of the Western world. It is interesting to reflect that we have this heritage, so often called priceless, because Cézanne could not afford to keep his woman and little Paul, their bastard.

Not that young Paul remained a bastard. Everything ended up happily. Cézanne married Hortense, father increased his allowance and conveniently died, happy no doubt, six months later, with Cézanne as his heir. And Cézanne, at last, was hung in the Salon.

Claude Monet (1840–1926) fits the legend much better, for few artists were so consistently and clamorously flat broke as he was. Since I shall quote from his dramatically begging letters, we should note at this point that a hundred francs of those days has been reckoned as being worth fifty dollars of our money. I offer it as some sort of measuring stick, but it should be taken with due reserve.*

Claude Monet was born in Le Havre in 1840 to the owner of a general food store. M. Monet was not poor,

* During the Franco-Prussian War and immediately afterward, France, and particularly Paris, suffered from a sharp inflation, and the price of food and lodging rose steeply. Things settled down after that and the later years of the Impressionists saw a more stable economy.

neither was he rich. He was a comfortable member of
the petit bourgeoisie, and as such had ambitions that his
son would rise in the social ladder. He therefore chris-
tened him Oscar. Young Oscar was a handful. He
played truant from school, scribbled all over his exercise
books, and detested the name Oscar. Nobody knew what
to do with him, and to the end of his life, when it was
quite clear that he was one of the immortals, nobody
ever did. He remained a puzzle, even to his fellow
Impressionists.

What I shall go on to record, in obedience to my
theme, must often seem sordid, so perhaps I may be
allowed a brief parenthesis to express my opinion of his
works. Having studied them for many years, I believe
him to be one of the greatest *painters* in the history of art.
His achievements have been dimmed by the influence of
Cézanne. Cézanne was a theorist—"See nature in terms
of cylinders and prisms," he said (albeit reluctantly; he
was no art teacher)—and ever since artists have seen the
world according to one theory (or "concept") or an-
other. I think that when that period has passed (and it is
passing) the greatness of Monet will come clear. He saw
the world in terms of *paint*.

Of course, like all the Impressionists, he claimed to
have a theory. He was, like the others, a "realist" and
recorded the real things under the various aspects of
sunlight, cloud, and so forth. It is a beguiling idea, and
for a long time I looked at Monet with that in my head.
Then, after mature study, I realized that Monet was not
painting reality at all. He did a celebrated series of
paintings of the cathedral at Rouen under various types

of light. Famous at long last, he did another series, this time of pictures of haystacks.

No Gothic cathedral has ever looked like Monet's pictures of Rouen and none ever will until somebody builds one of colored blanc-mange. No self-respecting horse would ever eat the hay of Monet's haystacks. What he did was to take the reality in front of him and use it as a jumping-off point to create something entirely new out of paints on canvas, something so utterly original that, now the magic of his hand has gone to the grave, the like will never be seen again.

When Oscar was a mere sixteen, he drew caricatures of the locals. They were exhibited in the shop window of a picture-framer and drew amused spectators. His mother was proud of the boy, but was very shocked when she found he was quietly selling them off at twenty francs. Oscar did not spend the money. He gave it to a favorite aunt to keep for him. For himself, he just took the small change, any boy's usual pocket money.

It was a significant act. Small amounts of money were always of great importance to Monet throughout his life. But it is rare for any teenager to save money that, to Oscar, must have seemed to come out of the blue. Did he perhaps forsee the bitter struggle that was ahead of him? We cannot say; all that we know is that his fellow Impressionists, dismayed by his constant lack of funds, noted that he was, at the same time, the sharpest businessman among them—too sharp, said those with money coming in from Papa.

Unlike Cézanne's father, Monet's was sympathetic

to Oscar's desire to be a painter. He wrote a letter to a local committee that had a grant in its gift for young artists. He praised his son generously: he frankly admitted that he did not have the spare cash to send him to the École des Beaux Arts in Paris. He asked for the award.

The provincial French, even today, know little about art, but they do know that it is something to be considered with solemnity. Young Oscar's caricatures showed that he had a light mind (not to say an eye for provincial absurdities). The committee turned him down as being too frivolous.

Monet *père* rose to the occasion. He gave his son money to go to Paris and join the École. Monet went, but he turned his back on the school. He studied instead at a private studio that was part dentist's surgery. There was a ding-dong battle between father and son, and Claude (as we must now call him, for that was the name he preferred) played truant.

Then he was called up in the draft. This took seven long years out of a young man's life, seven years defending the glory of France—provided he could not find someone to buy him out of it. Monet *père* offered to do so, provided his son would give up his truant ways and settle down. Monet refused. He wrote a letter to a friend explaining why. It was full of gush about a life of adventure, golden deserts, and so forth—a combination of Ouida and The Sheik of Araby. It is plainly false. Monet was determined to keep his freedom, even if paradoxically it meant joining the Army. But Monet was a bundle of paradoxes.

In 1862 he was serving in Algeria when he fell seriously ill. This time Monet *père* again did the handsome thing. He bought the boy out of the Army and let him go his own way. There was no private income for him. The family did what it could, when it could. Monet was happy. He was sure that he would get by. Had he not paid for his Paris truancy out of the money he had wisely asked his aunt to save for him?

It was magnificent, but Monet was no longer a boy who could get by with a few centimes in the pocket of his breeches. He was a man, and, moreover, a man with a mistress.

Camille Doncieux was a mistress whose face is as familiar as that of any of the great courtesans of history, yet curiously it is difficult to decide exactly what she looked like. That is because she was painted by two geniuses, both completely pig-headed when it came to putting brush to canvas. She was painted over and over again by Monet. She was also painted by Renoir. Monet used her as a clotheshorse, and one of his first paintings to attract attention was of her in an enormous skirt. She looks slender and a little fragile. Renoir had no use for slender women, so he fattened her up and gave her that stupid but sexy look that most of his women carry. She hangs now in famous galleries, and walking around them one can deduce only that she was amiable (she is obviously a patient model), that she had a retroussé nose (but Monet would alter it according to the way the sun

shone on it), and that her eyes were large and set wide apart. One other thing is noticeable in all her pictures. Her mouth, which was small, droops more and more as the years go by, and at last it sets in a bitter line.

No wonder: she lived with Monet thirteen years and finally became Madame Monet. But they were terrible years, both for her and her son. The boy sprawls happily enough on the grass by her side in pictures by both Monet and Renoir (Renoir painted her to show Monet how it should be done), but there were many times when the little man did not have enough to eat.

The Salon refused Monet's pictures, one might almost say, with enthusiasm. People would not buy them. Money again and again ran out, and there was no piggy-bank for Aunt to break open in a crisis—and there was one financial crisis after another.

Such money as there was came from a painter friend, Frédéric Bazille, one of those of the Café Guerbois who had a small private income. He managed to supply Monet with fifty francs a month, but that clearly was not enough to live on. At an exhibition of seascapes in his native Le Havre, he got a silver medal, but no money. That year he could not even buy coal to keep Camille and her baby warm. Monet was profoundly depressed. Or was he? Here are the facts as told by himself. In the spring of 1868 he writes to Bazille. He tells him he has received a commission for a portrait:

> but all that is not enough to bring back my old ardor [for painting]. My painting doesn't go, and I quite definitely count no more upon Glory. My morale is way down. To

put it shortly, I've done nothing since we parted. I've become lazy, when I would like to set about working, I feel bored, I see everything in gloomy hues. And, moreover, money is always lacking. At the Le Havre show I sold nothing. I got a silver medal worth 15 francs [he had plainly been to the pawnshop], some splendid reviews in the local rags, and that's all. That sort of thing doesn't give one anything to eat. Meantime, I've sold a picture to some advantage—not moneywise, but for the future, even if I don't believe in the future any more.

It is all very sad, but Monet was as yet only twenty-eight, and he had two commissions and a medal, not at all bad for an artist who was fighting the Establishment.

Things got dramatically worse. On June 29 of that year he wrote again from Fécamp to Bazille:

I write you a couple of lines in great haste to ask you for help as quickly as possible. There's no doubt about it, I was born under an unlucky star. They've thrown me out of the inn, stripped of everything. I've sent Camille and the poor little kid into the country for safety. I'm leaving this evening for Le Havre to try and get something out of an admirer. My family doesn't want to do a thing for me. So I don't know where I'm going to sleep tomorrow. Your much tormented friend, *Monet*. P.S. Yesterday I was so upset I was silly enough to try to drown myself. Fortunately no harm done.

The picture of Monet flinging himself into the sea and then striking out for the shore when he found it was wet is intriguing (all his life he had a gift for keeping afloat in every sense). However much one suspects that

the letter was a touch, one thing is certain. There was no room at the inn for Monet.

All was well by September. He wrote once more to Bazille. He had left Le Havre and was back in Fécamp, where the innkeeper had thrown him out.

> Here I am surrounded by everything I love [exclusive, one imagines, of mine host]. I pass my time in the open air or on the rocks on the beach, when it's bad weather, or when the fishing boats set out: or I go into the country, here it's so beautiful that I find, perhaps, that the winter is more pleasant than the summer. And, naturally, I work all the time. Then, when evening comes, dear friend, I find a fine fire in my little home, and a lovely family. If only you could see my little son, how sweet he's become. Friend, it's wonderful to watch the little fellow grow, and I swear I'm as happy as can be to have him. I want to paint a picture of him for the Salon, with some people standing round, the way they like it. . . . Thanks to that gentleman in Le Havre, I enjoy the utmost tranquility.

It may seem strange that this rebel against the Establishment should think of doing an avowedly commercial picture of a little boy to get into the Salon, but the Impressionists were not only "realist" painters, they were real people. The consistent cultural rebel is rare to come upon in life, and when you do he is often achingly tedious. In any case, the picture would certainly have been rejected, as were those, years later, of the then-pubescent boy. It would have been pure Monet. His hand could do no other.

He was incapable of organizing the elaborate fraud of another Impressionist, their leader and guru. "The principal person in a picture is light," he had said as he laid down the law in the Café Guerbois. The guru, Éduard Manet (1832–1883), confided to a friend that "all I want now is to make money" and fell for a trick suggested to him by a journalist friend, Théodore Duret. The writer commissioned a portrait of himself in the Salon style—standing, neatly clothed up to the hat on his head, and leaning in a thoroughly respectable manner on that emblem of gentility, the walking stick. Manet was to sign it, but *backward,* in a scribble difficult to read. Thus everybody would take it to be a portrait by one of the Establishment, and then, "Hop-la!" it would be revealed that it was by the rebel. The trick did not succeed, but what is interesting is that the "principal person" in the picture is not "light" but Théodore Duret, who paid for it.

So we may forgive Monet (I am returning to the one who was broke—their names were confused in their lifetimes by art critics who also confused their pictures) for his passing dream of a chocolate-box picture of his baby being hung on the line and of finally making real money. *On the line* needs explaining because it gives a glimpse of what the Salon was really like. It was a commercial institution and was organized something on the principles of our supermarkets. As many pictures as possible were crammed on the walls, three rows high. *On the line* meant eye-level. The painters who were "skied" did not seem to object too much; the thing was to be hung.

Monet preferred to go on borrowing money from his friends. Six years later, or perhaps sooner (there is doubt about the date of the letter), he is still penniless. He writes to Manet: "It's getting harder than ever. From the day before yesterday [I am] without a sou and without credit, either from the butcher or the banker. . . . Could you send me by return of post a currency note for 20 francs? It would be a help to me for the moment."

Manet, however, was off on a voyage to Venice. Monet writes to another friend: "I'm absolutely desperate: they will take away everything [the bailiffs, that is] just when I was hoping to get my affairs in order. When I'm out on the street and with nothing left, there will be only one solution left to me—to take up any old job. It will be a terrible blow and I don't even want to think of it and I'm making a last effort. With 500 francs I can save the situation. I've got about 25 canvases by me. I'll give them to you at that price. If you take them, you'll save me."

That works out at twenty francs a picture, but prices for the Impressionists were at the bottom. A Pissarro once went for seven francs. However, Monet's richer friends and admirers did give him money in return for his paintings, but in 1877 he was in low water again, and particularly muddy waters—Camille was expecting a second child. He writes to Victor Chocquet: "Would you have the goodness to take one or two daubs and I will leave you to name the price—50, or 40 francs, whatever you can pay, because I can't wait."

Théodore Duret was worried about him, and Manet thinks up a plan:

I went to see Monet yesterday [he writes to Duret] and I found him a wreck and desperate. He asked me to find someone who would take ten or twenty pictures at 100 francs a piece. Shall we arrange things between our two selves, say at 500 francs a picture? It should be understood that no one, least of all him, should know that the offer comes from us. I've thought about a dealer or a collector but I foresee a refusal. Unfortunately only we can do it and at the same time as getting a bargain help a man of talent.

Duret turned the suggestion down, but it would appear he, too, sniffed a bargain, or at least one which might, over the years, prove one. He offered to buy some paintings for 1000 francs. This paid off some of Monet's most pressing creditors, but trouble faced him in April of 1878. Camille was about to give birth. He writes to his doctor, Paul Gachet, that delivery was expected from one moment to another, and asks him if he can send some money, even though Monet is already in debt to him. The good doctor sent fifty francs. It was, of course, not enough, but the baby was born, a healthy boy. He writes to Zola:

Can you help me? There is not a sou in the house, not even to boil some hot water. Worse, my wife is sick and is in need of medical help. Perhaps as you already know, she's given birth to a fine boy. Can you lend me two or three *louis*, or even just one? I spent all yesterday without finding a centime.

Dr. Gachet was not, however, off the hook. Almost immediately after the happy event, Monet decided to

move to avoid his creditors. The scheme failed dismally.
He writes to Gachet: "I thought of asking you for a
favor, but I did not dare, our furniture is all loaded up
on the van, but I can't pay the moving men, not a cent."

If the reader feels that all this is getting too much
like a high-minded movie with a message, he is sharing
the exasperation of the Impressionists themselves. They
held shows (The Independents, they called themselves),
but a less independent group of painters is hard to
imagine. They were either living off their fathers, or
wives, or aunts, or (that last resort of neglected French
genius) the Americans in Paris. Among them was Mary
Cassatt (1845–1926). The daughter of a rich Pittsburgh
banker, she came to Paris to be an artist against her
father's advice. She had many friends among the
painters for the Salon. They, surveying her pictures,
told her, with that courtesy for which the French are
famous, that her father was not wholly in the wrong.
Mary, who had the sturdy resilience of the American
woman so well exemplified by *Annie Get Your Gun*, went
and got lessons from Degas. He was a somewhat difficult
member of the Impressionist group (he sold his pictures
to an opera singer who kept him going and he was
inclined to look down upon—and sometimes bawl out—
his fellow travelers). Mary Cassatt, whose own pictures
speak for themselves, bought when she could, but there
was no doubt about it, the whole situation was thor-
oughly unbusinesslike, especially for a lady in her
middle thirties from Allegheny City, Pennsylvania.

She saved Durand-Ruel from bankruptcy and if
Monet is the father of Impressionism, she has a claim to

be the fairy godmother. Without Durand-Ruel, it is possible that the works of the Impressionists would today be moldering in attics. He is the hero of the story and, astonishingly enough, a picture dealer. An *honest* one.

He bought the Impressionists, although he could not sell them. He stored Cézannes away in his cellar, and they were joined by other canvases of other Impressionists in large numbers. He even managed to straighten out Monet's affairs. Monet was running out of really moving disasters for his begging letters. Neither of the two boys developed a fatal disease, and Camille held up. Paul Durand-Ruel (1831–1922) made the sensible suggestion that he would give Monet a regular income, varying according to the market each year, in return for all the pictures he could paint.

The device is much used by dealers in our own time. It is an honest deal, but it can be trying to an artist. The distinguished English painter Duncan Grant was for several years my friend. I remember the celebration we had when he signed a contract with Agnews, the London dealer, for a thousand pounds a year for a stated number of pictures (I forget how many, but it was quite a lot). All went well until the end of the year, when I would find Duncan slapping away furiously to catch up.

But at least Durand-Ruel had brought some order into the affairs of the Impressionists. Not all, by any means, signed up with him, but they knew that there was a man who would give them money for their canvases with the minimum of argument.

Why did he do it? Durand-Ruel has gone down in

the history books as saying that in his opinion a dealer should follow his own taste, and not the current demands of the marketplace. Every picture dealer I have ever known has said the same thing, and it is remarkable how wide their personal taste is and how often it coincides with that of the public of the moment. Durand-Ruel was not entirely a knight in shining armor. His father had been a picture dealer before him and had bought painters of the Barbizon group when they were being equally criticized, among them Millet, Courbet, and Corot. They had come into fashion, especially with the Americans. America was particularly enthusiastic about Corot, and generously bought more Corots than he ever painted. Durand-Ruel had therefore a sound foundation for taking a risk. But it was a big risk, much bigger than his father took. The Salon continued to refuse the Impressionists, and if by chance anything of the type slipped by, advanced art lovers got cricks in their necks because it would be skied. The stalwarts of the group, however, were consistently refused.

They held exhibitions on their own. The public no longer came to jeer: they hardly came at all. Zola had done something toward tempering the winter winds of the art critics. Yet they continued to complain that the pictures were hasty and unfinished, that nobody had ever seen a purple poplar tree (so what was this vaunted "realism"?), but above all they deplored the lack of Good Taste in the subjects chosen and the models employed. They admitted that the Impressionists were sincere; they agreed that they had talent (a fact often ignored by some writers today who do not seem to have read the

actual reviews); they concurred that the pictures could not be ignored. But why were they all so Vulgar? It is interesting to go around an Impressionist gallery trying to think like the critics, looking at the groups picnicking, sailing, eating in restaurants, watching shows, and so forth. Monet hit the nail on the head when he painted *The Bar at the Folies-Bergère.* As a painting, it is masterly. But not everybody finds young barmaids fascinating, at least not after they have got over their twenties.

America, then as now, was more democratic in its views. The first country in the history of mankind in which every man was truly equal to his fellow, the last half of the nineteenth century saw a number of Americans who wished they were not. This led to culture, Henry James, and the financial salvation of the Impressionists. Durand-Ruel had a brilliant notion of calling in the New World to redress the bank balances of the Old.

He cautiously introduced Monet, Renoir, and others to the American public. We have already seen that owing to the sagacity of his father he had a stock of the Barbizon school—Courbet, Corot, and others, but particularly Corot. Like Corot, the Impressionists were a bit muzzy in style and some American critics wondered if they could really paint at all. But Durand-Ruel, avoiding the question, tactfully pointed out that they were French, and that won the day. One of the fashionable ways of raising oneself above other Americans

without violating the Constitution was to go to Paris. People who had been there willingly bought pictures that had been talked about in that capital city and put them on their walls as a reminder. They were talking pieces, which fortunately could not talk back and make those disagreeable French noises.

The art critics said the usual things, but mildly, the New York *Herald-Tribune* resorting to the cautious journalistic device saying "It is said that . . ." The public, however, bought. It was as well they did. Durand-Ruel was teetering on the edge of bankruptcy. Mary Cassatt did her best to help, but far more usefully, she threw herself into convincing the American public that here were painters as good as Corot and Courbet.

Durand-Ruel's troubles were caused by an *economic crisis* in France. It is a phrase which will give any young artist pause to think because nowadays he hears it so often. It is a curious circumlocution. The word *economy* comes from two innocent Greek words meaning "the manager of the household." In the case of a nation, a *crisis* occurs in the "household" when the rent collector is hammering at the door, two men are moving out the stereo set, the cook is packing her bags, and husband and wife are throwing plates at each other over the credit-card bills. At this point the "manager" remarks sagely that it would be difficult to say what is happening exactly in the household, but that he can see a light at the end of the tunnel.

If an artist is to paint and eat in a free world, he must face this chaos in which he lives. If he is young, prayer is the only thing. If he is established, by a strange

twist of fate, he is one of the few citizens who can make money out of it. People will buy him as an investment.

Much the same thing happened in France. People who had bought the Barbizon group from Durand-Ruel's father and his son dirt-cheap could now sell them at a handsome profit, principally to the Americans on the odds that much the same thing could happen with the Impressionists. Prices began to climb; the Salon showed interest; and, I regret to tell those of a romantic disposition, the Impressionists broke into a stampede to exhibit on its hated walls.

Renoir led it. His buxom women were pleasing to current taste. They resembled the furniture the Great Exhibition in London in 1851 had made popular—they were overstuffed and comfortable. One of the firmest principles of the Impressionists had been that if you wanted to paint Nature you went outdoors. The cow brought into the studio was absurd. Renoir sensed which way the wind was blowing, and it wasn't over the cow pastures. A Madame Charpentier commissioned him to paint her and her two charming little tots. She was a rich member of the bourgeoisie with a heavily furnished house. Renoir gave up all his theories and came in from the cold. He painted her at home. She had, after all, offered to pay one thousand francs. The Impressionists had attacked the use of black in pictures because the Establishment used it to depict shadows, which the Impressionists said (correctly) were never black. Mme.

Charpentier had a black frock from Paris. She posed in it. Renoir painted it. She had a touch of white at her throat and wrists, and perhaps that salved Renoir's conscience; or possibly, with 1000 francs in view, it was taking a well-earned nap. As another Impressionist, Pissarro, said when he heard about Renoir's defection, "Poverty is a hard thing."

The Impressionists had always been accused of not being able to draw, an opinion with which our Italian bride in the National Gallery agreed and that so annoyed her husband. Renoir posed the two little children a foot or two apart. One looks up at the ceiling as though she is expecting it to fall down. The other gazes at her with an expression that seems to say that her idiot sister has got another silly idea in her head. Renoir was trying hard, but it was plain that he felt worried about the way he had posed the children. So he put an enormous dog between them. The dog has its muzzle pointed toward the spectator. Now, anybody who has to sketch the family pet knows that this is an extremely difficult angle. The nose and ears come out all right but as the drawing progresses backward the animal is inclined to look more and more like something out of the Carboniferous Age. Renoir neatly solved the problem by sitting the little girl on the dog's hindquarters. The picture now hangs in the Metropolitan Museum in New York. Our Italian bride's little brother could find a dozen things wrong with it, and so can any student of art. But it had one thing resoundingly right. It was accepted by the Salon.

From that day on, Renoir went from success to

success. With the money he made, he traveled. He visited Pompeii and saw the frescoes on the walls of the houses. The longer he studied them the more convinced he became that the Establishment critics were right. He could not draw. He set himself to remedy the defect. One of the things his Impressionist friends had always fought against was the hard line the Salon painters drew around their human figures. There were, they maintained, no hard outlines around real people. Renoir returned to France, painted away vigorously, and there, his Impressionist colleagues sadly noticed, were the outlines.

But the Impressionist group was breaking up. Cézanne said he would have no objection to exhibiting in the Salon; so did Alfred Sisley (1840–1899); so did Manet, and of this latter's success it is sufficient to say that the rebel against the Establishment ended up as a Chevalier of the Legion of Honor and, what is more, liked it.

What of Monet? The few remaining hard-core Impressionists regarded him anxiously. Would he go over? He was the father of the movement, but, alas!, he was also the father of two sons. He went over. Six years later he was at the top of the tree. His haystacks were selling at 3000 and 4000 francs apiece and one picture, sold in America, brought the handsome sum of 9000 francs.

Into the dwindling group of rebels one day came a painter full of that zeal to break new ground that had once inspired Monet and had sustained him through his troubles. This new recruit was Paul Gauguin, the painter

of the picture that was sold in an auction at a price which so pleased Picasso. Gauguin's story is so well known it does not need repeating. The rebel par excellence, he died on a Pacific island in circumstances as romantic as it is possible to conceive. It would seem that he, when he came to Paris, would be the exactly right person who could rouse Monet's enthusiasm, the man to carry forward the banner of revolt.

Monet, now flush, saw a picture or two and gave him the nod. But later, still richer, he withdrew his opinion. "I never," he said, "took Gauguin seriously."

Chapter 11

Fakers
Triumphant

For a moment, I wish to turn our attention away from artists to those people who gave them their remittances, who commissioned pictures, who bought them off gallery walls—in a word, the bourgeoisie. Excuse my French: there is not a word in any other language I know that so accurately defines them. No nation has hated the bourgeoisie more bitterly and more brilliantly than the French; nor has any nation so deliberately based its civilization and its culture upon them. The French artist, the French writer, the French intellectual by and large, when he sets foot on the first rung of the ladder of fame, always says he proposes to kick it down.

This is a noble sentiment, and pretty safe. When he gets to the top, he changes his mind, and this, as everyone will recognize, shows prudence.

The bourgeoisie decided that there was money in the Independents. As the old warriors went to their rest, new ones took their places. To sum up the change of opinion let us take one customs official who could not draw and had taught himself to paint. Customs officials have to have a certain shrewd knowledge of human nature and Le Douanier, Henri Rousseau, the painter with whom I am dealing, very wisely never did learn to draw, at least not publicly. All the same, he was a success. He joined a group of the new Independents. This new band of artists included a young Spaniard who could not only draw and paint, but could also be guaranteed to change his style every few years to something more shocking and incomprehensible than before—just what the bourgeoisie wanted. The Impressionists had proved there was money in being outrageous. The young Spaniard, Pablo Picasso, never had any money difficulties throughout his long and celebrated life.

But there is something else about the bourgeoisie that young people, not as gifted as Pablo Picasso, take a long time to learn. It always comes as a surprise that rich Uncle James, so well-heeled and secure, once had the pants taken off him by his best business friend. And it is fascinating to sit at Grandma's feet and listen to how that foreign countess got away with half grandfather's fortune when she wasn't a countess at all. The bourgeoisie, then, are open to be deceived.

Deceived they were, and still are, by a series of

joyous crooks from whom I propose to take a few choice specimens. Let us first take firm hold on two platitudes—for that is exactly what the crooks did and do. "A thing of beauty is a joy forever" is the first. The second is that "Beauty is in the eye of the beholder." When you add that the eye of the beholder is looking around for a safe investment in a work of art, he can turn out to be as big an idiot as Uncle James.

When Uncle James bought a piece of furniture it was made of solid wood. Natives had sweated in jungles to cut down the mahogany or teak trees. Docile elephants may well have hauled it miles. Joiners and carpenters had labored for days in putting the wood into the required shape. It was the same with Madame's ample frocks, those Monet and Renoir painted to get into the Salon. Putting aside the silkworms that obstinately spun solely for their own instinctive pleasure, the tucks and frills and embroidery were done by nimble fingers. The seams of Monsieur's ample trousers were sewn in the same way. There were people who said that Madame and Monsieur covered their nakedness from the products of sweatshops, but there were always people who would say anything to draw attention to themselves. Had not some anarchist made the preposterous statement that property was theft? Oo là là!

It was the same when you ordered a painting from one of the Establishment. One could be sure that one was getting hours, days, weeks of painstaking labor for

one's good money. It gave one a sense of stability and security such as one derived from a thoroughly discreet mistress.

The rise to success of the Impressionists presented a problem that is with us today. In school, our children are encouraged to express themselves by daubing paint freely on paper, a theory first advanced by Britain's most distinguished art critic, Herbert (later Sir Herbert) Read, whose writings can be found in any good anthology of anarchist literature, for he was proud to declare that anarchism was his firmly held political belief.

Now suppose some unprincipled art mistress set her clan of infants to stand round a large canvas and dribble paint on it. Suppose this evil woman then forged the signature *Jackson Pollock* on it. Would she not give the next meeting of the Parent-Teacher Association a lively topic for discussion? One of the leading gallery owners of Milan, Signor Ghiringhelli, assured me she would. He should know. I asked him the question in the late 1950s, when Milanese businessmen were stripping his gallery of Italian imitations of the New York School and putting them away (according to Ghiringhelli) in bins.

Now, the Impressionists did not take elaborate pains over their paintings. They aimed to catch the fleeting play of light and shadow, nothing more. If the picture did not come off, they abandoned it and tried again next day. There was no laborious tinkering with fine brushes. In his old age, a muscular disease crippled both of Renoir's hands. He continued to paint with a brush strapped to his fist. The results are among his greatest paintings.

Such work is as easy to fake as Jackson Pollock and his followers, and the fakes, as Signor Ghiringhelli cheerfully admitted, were almost impossible to detect. Uncle James, deprived of the use of his common sense that told him he was buying good hard work for his money, was in a dilemma. It would seem that anybody could paint a Corot or a Monet, and as for signatures, they could be as easily forged as they could be on checks.

There was one way out. If the artist was living Uncle James could get him to authenticate the work and have a document in the bank to prove it. This was done, and while the nineteenth century lasted it was useful. People were serious in those days. But in our own times, artists have developed a sense of humor. I shall now trace how this arose.

I begin with a good old-fashioned faker, who gave solid value for the money, a man of the stamp of Nollekens. He was Hans van Meergeren (1889–1947). He was a man who took endless pains over his job and did not begrudge the hours he spent at it. Fakes don't come like that nowadays. He selected the most difficult of artists to copy, especially Vermeer, whose surviving paintings were very few. Vermeer painted light long before the Impressionists, but never in haste. His *View of Delft*, one of the immortal paintings in the history of art, is merely of a row of undistinguished houses seen across

a canal. But the atmospheric effect he produced was unequaled by even the greatest Impressionists.

Van Meergeren invented Vermeers of his own. He even sold these to gallery owners and directors. His fakes brought him in over two and a half million dollars. He was exposed and imprisoned for a year. His punishment, however, was not inflicted for his faking. He was jailed for collaborating with the Nazis during World War II. The sentence I consider admirable. Van Meergeren was Dutch. The judge was Dutch. Collaborating with such canaille as the Nazis was a strain on the character of a good, hard-working Dutch citizen and had to be paid for.

The story has, I regret to say, an anticlimax. In the 1950s about a dozen of van Meergeren's fakes were put on show in the Gran Palais in Paris. I went to see them. They were, one and all, very bad. It is difficult to see why the owner of a publicly supported art gallery would ever have been persuaded (and by what means) to accept them. I merely record that van Meergeren died without a cent to his name.

The fakers now had the easiest of marks. The Impressionists had upset the apple-cart. The Post-Impressionists, as they had been named by the London art critic Roger Fry, had produced sheer anarchy. Mr. Fry, a small mild person, was an acquaintance of mine. He was a man with whom it was deeply interesting to

take afternoon tea. One climbed to the appointment some steep stairs in a Bloomsbury apartment, the wall of the stairs being lined with priceless works of Cézanne, Matisse, and others. Over the teacups Fry would explain his pictures to the young such as myself. He said we must look for "significant form," a term much current in Bloomsbury in those days.

On one occasion, my mental processes stimulated by the tea, I ventured on an antonym. What, I said, would be *in*significant form? In the ensuing silence, a second cup of tea was proffered, sipping which, I suggested that a very insignificant form would be a fried egg. A week later I was mortified. Going around an art dealer's gallery just off Piccadilly, the owner offered me a small oil by Pablo Picasso (then virtually unknown in England) for the reasonable sum of fifteen pounds (then seventy-five dollars), frame and all. It was a painting of a fried egg.

The truth was that after the followers of the Impressionists had thrown out all the rules, throwing over the rules became itself the creative act. Constantin Brancusi, possibly the most authentic genius of the twentieth century, created a smooth piece of metal and called it *Bird in Flight.* Sent by dealers to America, the U.S. Customs insisted that it was a piece of machinery, and dutiable. The dealers and critics created the most splendid uproar and the price of the *Bird* soared. The U.S. Customs were, however, quite right. The metal sculpture can be seen in the Tate Gallery, London. It certainly is a piece of machinery. When I last paid it a visit I was surrounded by a group of schoolchildren.

More than one remarked that it looked like the supersonic airliner, the Concorde, stood on its tail. Brancusi, however, had done the bird decades before that airplane had ever been thought out.

Years of sweat and experiment were behind the *Bird,* but *they do not show.* A faker could run up a clay model for casting of the same sort of thing in a couple of hours. Paintings were much the same. The fakers turned them out by the thousand. Nowadays Uncle James has cultivated his sensibilities. His trousers are no longer ample. He wears jeans but, like his unfortunate Victorian predecessor, when he walks into a dealer's gallery, he can still have them taken off him.

Let him beware, for instance, of Maurice Utrillo's (1883–1955) charming views of French streets. Utrillo was a prodigious worker except when he was sober, which, fortunately for us, was almost never. Few artists could put forward a claim to psychic wounds as good as Utrillo. He was the son of a trapeze artist, not in itself the inevitable cause of a trauma, but she fell off. This led to her taking up posing for artists to earn a living and subsequently to become a painter herself. She was now on terra firma, but she was still not safe. She was raped by a drunk, and Maurice was born.

He took to drink when he was so young that it was clear that nothing could be done about it when he arrived at a legally responsible age. He too painted, in the Impressionistic, Post-Impressionistic style. He too went out into the streets and alleys to catch the real effects of the play of light. Sometimes, on the other hand, warned of the perils of falling down by his

mother's history, he would stay at home and paint from picture post cards.

There is a catalogue of his known works. It lists four thousand canvases known to be genuine and one thousand known to be fakes. Some of these I have seen during my travels about the world, hung on the walls of people kindly giving me lunch or dinner. As distinct from the van Meergerens, they are excellent fakes. Beauty, as we have seen, being in the eye of the purchaser, I join their hospitable board and hold my peace.

But it is difficult to suppress the story of one of Utrillo's fakers. When Utrillo was too drunk to hold a brush, his dealer, who was doing a brisk business, took up the palette and painted a picture for him, carried it off and sold it. As a Utrillo, naturally.

It is impossible not to find something attractive in the lifestyle of Utrillo's dealer. Obviously a man of talent, he lent a helping hand (in the most practical sense of the phrase) to another man of talent who was an alcoholic. He was a one-man Alcoholics Anonymous.

Utrillo had another friend. She was called, by everybody, Zezí du Montparnasse, a name redolent of sequins, the cancan, and frilly drawers. She was, however, a hard-working woman. Montparnasse is not Montmartre, where artists were congregating. It is the quarter around the ancient univeristy of the Sorbonne

and its principal inhabitants are students. Zezí was not a student but she was a quick learner. She also undertook to turn out a Utrillo on the days when that genius was feeling poorly. She charged the very reasonable rates of a hundred to three hundred francs a picture, according to the area to be covered.

If one is tempted to disparage Zezí (and there are such people) one might say that Utrillo, who did not despise picture-post-card views, was an easy man to copy. But Zezí had greater depths. She could even copy Picasso at the same price. Pablo Picasso was still young and bubbling with his myriad inventive notions. He was the chameleon of the art world, and Zezí did not copy the evening edition of his style. She copied what he had already abandoned.

It is pure sentimentality, but I like to think that the fake Utrillo I saw hanging in the dining room of a Georgetown house in Washington was by Zezí. Its owner, a great admirer of Utrillo, assured me it had cost him a lot of money. It could well have done; 70,000 francs was once paid for a Zezí-Utrillo, and that was decades ago.

But could not Uncle James go to the artists, show them the work before buying, and ask if it were genuine? As we have seen, in the early days of the revolution, he could. This new generation was difficult. Picasso and Utrillo had what Uncle James would undoubtedly call "the artistic temperament." These impudent bounders actually took a hand in swindling him.

Utrillo was all generous admiration for his fakers. Shown one of their works, he said, "I might have

painted it myself." This being so, there was no reason he should not authenticate it, which he did.

Or was there a reason? The Jesuits are masters of the art of casuistry, a system of carefully arguing the pros and cons of moral dilemmas. I once asked a highly cultivated Jesuit father what was the moral position of Utrillo. He thought about it and said: "If he was a practicing Catholic he should confess. If he confessed to *me*, I would give him three Hail Marys and absolution, with the recommendation to say them as quickly as he could and get back to his studio."

Pablo Picasso was not a religious man. His attitude, when faced with the innumerable fakes of his work, is thoroughly pragmatic. "If I like it," he announced, "I sign it."

Giorgio de Chirico (1880–1979) was one of the most famous of the school of painting that followed Post-Impressionism. Known as the Metaphysical school, its paintings now fetch very high prices. They are an excellent investment. Outside Italy, the Metaphysical school is generally considered part of the Surrealist movement, of which the prime exponent is Salvador Dali, whose prices are as high as the tips of his waxed mustaches. Dali has continued to paint in this style, with variations, all his life.

De Chircio soon got tired of it, then completely disgusted. While dealers were selling his Metaphysicals for sky-high prices, de Chirico was saying that they were kitsch, junk, and any other epithet he could lay his tongue to, and since he was a lifelong resident of Rome, they were plentiful. He took to painting "after the style"

of the great masters, such as Rubens. Apart from an occasional shaggy-maned white horse, nothing remains from his Surrealist period. He mostly painted portraits of himself dressed up in various historical costumes.

De Chirico's Metaphysical paintings are extremely easy to copy; they call for little painterly skill, which is the main reason de Chirico disliked them. They often included the dummies on which makers of women's frocks to measure will work. For that reason, in the years of his best-selling fame, fashionable photographers would include his "metaphysical" objects in their pictures, this putting up the price of the original paintings.

De Chircio was determined to take his pictures off the market. He put his foot through any that were in his possession, but there remained the problem of the fakes, which were pouring out everywhere.

De Chircio saw a chance to deal the gallery owners a mortal blow. He went further than Picasso. He could not very well say that if he liked a fake, he would sign it. What he did say to avidly listening journalists was that the worse the fake the more he would authenticate it

A painter de Chirico greatly admired was Renato Peretti. Signor Peretti was also the most accomplished faker of de Chiricos. When de Chirico died at a venerable age, Peretti was promptly arrested. This caused a considerable scandal, not only among art dealers but, more effectively, among those super-rich Italians who had collected de Chiricos as a hedge against inflation. These multimillionaires already had a great deal to put up with. They were paying premiums to Lloyd's of London as an insurance against being kidnapped, and

the premiums were very heavy since more than two hundred kidnappings were taking place every year in the native land of Leonardo da Vinci and Michelangelo, against which the police (in a country where they shoot ex-prime ministers) were too busy to protect them.

Here were these same police arresting the only man who could say whether the millionaires' de Chiricos were worthless fakes or as good as (or better than) gold.

The dealers were equally shocked. They all knew Renato Peretti. He not only faked de Chiricos. He could turn out an excellent De Pisis, a modern artist the dealers were pushing as an excellent investment. True, De Pisis did not yet have an international reputation, but who had heard of Cézanne until he suddenly became blue-chip? Certainly not the millionaires.

Fortunately Peretti, besides his undeniable talent, possessed inner calm and a sense of humor. He was produced before the magistrates. Thundering charges of fraud were hurled at his head. The law, he was told, was hot on the tracks of swindlers like him who had brought shame on the name of Italy, the birthplace of Leonardo, etc., etc., etc.

The next day, with humble apologies, he was released. The police and the magistrates, overnight, had been brought face to face with the fact that the only man who could tell them (and the millionaires) what was a false de Chirico, De Pisis, and so on, was Signor Peretti.

A free man once more, Peretti graciously conceded interviews to the television and the press. We are fortunate in having his own musings on the situation, and I shall quote them.

"I want you to put down in your notebook," he said to one journalist, "that I am *not* a faker. I am an imitator. I have the profoundest admiration for true genius. I have never sold a single picture saying it was by de Chirico or De Pisis. I have always signed them 'Reni *da* de Chirico,' or 'Reni *da* De Pisis.' "

Da is a difficult word to translate into English. According to its usage, it can mean our old friend in our schoolboy Latin grammars, "by, with, or from."

Fortunately Sig. Renato Peretti saves us from going into semantics. "Indeed," he proceeded, "I have been informed that certain dealers, astonished by the perfection of my work, have canceled out 'Reni da.' Is that my fault?"

The *Stampa Sera* (*Evening Press*) is an old and serious newspaper. The reporter to whom he was speaking had done his homework. He respectfully pointed out that on certain verified occasions Sig. Peretti had, in his search for perfection, also imitated the signature of the artist.

Sig. Peretti not only rose to the occasion, he positively soared above it.

"Does not the signature form part of the composition?" he demanded. "Of course it does. Then how can I, as a painstaking imitator, ignore it? Exactly as a tailor, in making a suit, cannot ignore the buttons, neither can I. I repeat, I am an imitator. I am like an actor who repeats the lines written by someone else. Why, I ask you, cannot I be given the praise that is accorded a great pianist?"

It is a convincing argument, all the more so because Sig. Peretti is a little shaky on music. Great pianists by no

means faithfully repeat the composer note by note, tempo by tempo. The most thunderous applause usually comes when they markedly do not. I would like to write at this point that Sig. Peretti's excellence lies in the fact that in his "imitations" there is no *rubato:* that is, personal additions. Unfortunately, *rubato* also means "robbed," so let us move on.

Chapter 12

Auctioneers— or How the Rabbit Gets into the Hat

We began this inquiry with Picasso's joy at a huge price paid at auction for a painting by that artist whom Monet never took seriously—Gauguin. Picasso argued, rightly, that the price of his own Gauguins went up accordingly.

So, at the end of our road, let us look back to the point from which we set out—auctions. Surely here is a safe haven for Uncle James. In a free society, the price of anything is fixed by what people will pay for it. On racecourses, bookmakers' assistants make mysterious gestures to one another to convey how the public is, or is not, backing a horse to win. Outside infant schools, no greater clamor is made by human beings than in the

world's stock exchanges. This again is fixing a price by what people will, or will not, pay. An auction, whether for a houseful of furniture or for the works of the immortals with which we have been dealing, must, it would seem, be the same fair and sensible business.

Sotheby's and Christie's are the two top auctioneers of works of art, and they are acknowledged to be so the world over. They are dignified institutions, as dignified as the Vatican; more, in fact. You do not have to pay anything to become a Catholic, but it you wish to deal with Sotheby's or Christie's, either as buyer or seller, you pay a premium of 10 percent over and above their commission on the deal. That keeps away the hoi polloi, and both institutions readily admit that it is meant to do so.

Unkind people have distinguished between the two by saying that one consists of auctioneers pretending to be gentlemen and the other of gentlemen pretending to be auctioneers. I have conveniently forgotton which is which. Let us put aside the British snobbery (for both firms are British) and say that both are gentlemen's gentlemen.

If Uncle James decides to avail himself of their services in buying a picture, he will immediately feel a sense of security. The premises are opulent, the goods are on display, perfectly lit. All is honest and above board. If he is thinking of disposing instead of buying, there is none of the air of the pawnbroker about the place. He will be met by young men and women, very well informed, who will tell him the state of the market. As for buying, admission to the display is by catalogue, a

beautifully turned-out job and often expensive. In this both photographs and text exhaustively describe most of the objects—size, date, previous owners—everything he wants to know.

Is Uncle James, then, safe, as he treads the thick pile carpet? Yes, if he keeps his wits about him. Let us say he spots a Matisse drawing, one of those dashing heads that are so famous. As a true lover of art, he is moved. He looks at the catalogue. The information is of course more scarce than for an old master, but the identification is quite clear. "N° 1367," it says, "drawing in gouache 33 cms by 25 cms. Matisse."

That means it is a fake, or at least that the top brass of Sotheby's or Christie's darned well think it is. Of course, they can't be sure, and we have seen why in the preceding chapter. If somebody likes to believe it is genuine, who are they to argue? They are not gods; they are not infallible. They are simply honest men. They have doubts that it is a Matisse, so they catalogue it as Matisse. What could be fairer?

The next step will perhaps make the method clearer. Uncle James is much taken by a small sketch of the deposition of Christ. He looks in the catalogue and finds it is attributed to "P. P. Rubens." Now Uncle James knows that Rubens' Christian names were Peter Paul. Everything therefore looks shipshape.

But Sotheby's and Christie's are leaning over backward to be perfectly upright, if that phrase conveys what I mean. They have doubts about that *Deposition*. Is it really by Rubens, or by some pupil, or, in the words of Sig. Peretti, by an imitator? Their delicately refined

perceptions will not allow them to state that it is un-equivocally by the master. Other owners, it is true, have thought it was, and the list is there in the catalogue. So they ascribe it to P. P. Rubens.

Now, nobody ever called the master P. P. Nobody ever said, "I've just spent an hour watching Pee-Pee paint. Amazing man." It is difficult to recall, indeed, any famous artist who is known by his initials. That sort of thing is reserved for the executives of commercial corporations. "P. P. Rubens" expresses, tactfully, that the auctioneers feel a certain dubiety.

What happens when they haven't any doubts at all? Well, there is always something refreshingly frank about thoroughly honest men. They simply use the artist's Christian name—*Henri* Matisse, *Pablo* Picasso, *Paul* Gauguin.

To sum up, if Uncle James is eccentric enough to be putting together a collection of fakes and imitations, the auctioneers are the best place to buy them. They are practically guaranteed false—if, of course, he knows the ropes.

In the auction room itself all is quiet and decorous. An American judge makes more noise with his gavel than does the auctioneer. "Under the hammer" is a gloomy phrase, especially for one who sees his beloved possessions going that way. The auctioneers have sensed this, so the hammer has been tactfully abolished. In-

stead, the man on the rostrum holds a small ivory object rather like a cotton reel. A light tap indicates a sale.

The bidding, which may run up to and over a million dollars, is conducted with true British phlegm. True, few bidders are British; phlegm is now something you consult a doctor about in the admirable National Health Service, for which the British have sacrificed so much, including their art treasures. Nevertheless, the bidders, of whatever nationality, comport themselves with constraint. One may raise the bid by scratching his nose, another by removing his spectacles, another by tilting up his beard. All this is well known, but it can sometimes go too far. At least, Christie's thought so on one occasion.

A famous collector bid hundreds and thousands of dollars by doing absolutely nothing. "While I am sitting, I am bidding," he laid down. "When the bid goes over my limit, I shall merely rise and leave the room." Unfortunately, the auctioneer forgot this system and knocked—or tapped—down something the collector wanted very much to some other person. Since the collector had stayed in the bidding with his bottom, as arranged, he was furious and lawsuits were threatened.

But Christie's is a very old firm and knows how to sail over such contretemps. It was founded in 1770 by John Christie, who chose his time well. The French Revolution came along and he did very well out of the pictures, objets d'art, and furs which the emigrés brought over to England with them. The firm's takings in 1978 ran to over a hundred million pounds. The

prices that the ivory cotton reel mark off are truly astonishing. A picture Velásquez painted of his servant was sold in these quiet rooms (in 1970) for £2,200,000 ($4,620,000). Sotheby's does equally well.

Are these enormous prices reached by the simple process of nose-scratching or a firmly planted backside? For Uncle James' sake I would like to record that they were. But before he takes off his glasses and lands himself with a picture, there are one of two more he should know.

Rich men can be capricious. The celebrated dealer Duveen once went to the very heavy expense of making an illustrated book in full color of the pictures he had on hand and sending it to Henry Ford (the tin-lizzie one). Ford sent him a letter of thanks in which he said that his wife and he had got great pleasure out of turning over the pages of the book so kindly sent him. He added that his wife and he thought the reproductions so well done they did not feel the need of buying the pictures.

Rich men, then, are difficult to sell to. They cannot be pressured. When a picture comes up, they might not be in the room, nor their representatives. Museum directors might be temporarily short of funds or having trouble with the trustees. The auctioneers must protect themselves (and the seller) against this.

They therefore arrange for a bid that is known among them as being "off the wall."

The wall is a man of straw. He can be described, later, as "Anonymous," but too much of that will not do. He can be a dealer in the know, which gives him a name:

or the auctioneers can make up a name off the top of their heads. Christie's can be quite skittish about this last device. They favor the names of types of beer, or so it is reported.

The picture is auctioned off to this dummy bid, which may be made by post, telephone, or a nondescript "representative" in the hall. The ivory hammer comes down at, say, $200,000. Every painting by a famous artist has its recorded history (known as the provenance) that will accompany it in catalogues. The picture is now "worth" $200,000, though nobody has actually paid that sum. In due course, Mr. Anonymous, or Mr. Stout, or Mr. Porter sends the picture back to the auctioneers for putting up for sale. A year, two years, even more have passed. A prospective buyer studies his catalogue and sees that he will have to start bidding in six figures. And so, ultimately, the picture finds a home, maybe in a private collection, maybe in a public gallery. Not all the huge prices paid for pictures by the big names are arrived at in this way. But it is interesting to know that many are.

This procedure is not only used for the dead. Sometimes the figure paid for a living artist's work makes us raise our eyebrows. "Is he really *that* famous?" we ask ourselves. Well, Mr. Stout or Mr. Porter or Mr. Anonymous has thought so, at any rate. And who can blame the auctioneers for helping to make a contemporary painter rich?

We began with Picasso telling us about Art and Money and saying "I know, because I am very rich." I now would like to leave Uncle James, and the fakers, and the gallery owners, and the auctioneers. I would like to think of the painter or sculptor who, returning this book to the library, goes back to his bare studio. As I see him, he is not rich like Picasso; he is very poor. He is not dressed in fine clothes like Rubens; his father is not a banker, like Cézanne's. He is oppressed by his creditors, like Monet. He has been looted by his loved ones, like Leonardo. His family is always on his neck, like Michelangelo's. If, like Phidias, some multimillionaire's wife would commission him to do a chryselephantine statue of her, he would willingly steal some of the gold.

Taking up his brush he might well ask, "What, exactly, has Art to do with Money?"

In the last analysis, nothing very much. Art is about those masterpieces their creators leave behind them. It is about the mysterious thing, talent. That is something money cannot buy and poverty cannot suppress.

Which is just as well.